DATE			

BAKER & TAYLOR

DECO
TYPE

DECO TYPE

72 pt.

72 pt.

◆ ◆ ◆ ◆ ◆

STYLISH

42 pt.

ALPHABETS

36 pt.

OF THE '20s & '30s

24 pt.

STEVEN HELLER & LOUISE FILI

18 pt.

CHRONICLE BOOKS · SAN FRANCISCO

12 pt.

Deco Type would not be possible without the help of many people. Thanks to Tonya Hudson at Louise Fili Ltd. for her skilled design and production. Thanks to the crew at Chronicle: Bill LeBlond, our editor, for his devotion; Sarah Putman, editorial assistant; Michael Carabetta, art director; and Jill Jacobson, design coordinator.

Most of the materials used for this book come from the authors' personal collection of type catalogs, samples, and specimens. In addition, we are grateful to the archivists, librarians, and dealers who have directed our research and provided us with the typographic artifacts herein: James Fraser at Fairleigh Dickinson University, Elaine Lustig Cohen and Michael Sheehe of Ex Libris, Irving Oaklander of Oaklander Books, Robert and Dorothy Emerson of Emerson Books, Michael Weintraub of Weintraub Books, George Theofiles of Miscellaneous Man, David Batterham of Batterham Bookseller. Appreciation also goes to the following individuals for loaning specific items: Erik Spikermann, Mirko Ilić, Teresa Fernandes, Naum Kashdan, Jonathan Hoefler, Seymour Chwast. Finally, thanks to our agent, Sarah Jane Freymann, for her continued support.

Book design by Louise Fili and Tonya Hudson

Library of Congress Cataloging-in-Publication Data: Heller, Steven. Deco type: stylish alphabets of the '20s and '30s / Steven Heller & Louise Fili. p. cm. Includes bibliographical references. ISBN 0-8118-1135-2 (pbk.) 1. Alphabets. 2. Decoration and ornament-Art deco. I. Fili, Louise. II. Title. NK3625.A7H46 1997 745.6'197'09042—dc21 96-37088 CIP. Printed in Hong Kong. Distributed in Canada by Raincoast Books, 8680 Cambie Street, Vancouver, British Columbia V6P 6M9. 10 9 8 7 6 5 4 3 2 1 Chronicle Books, 85 Second Street, San Francisco, California 94105. Web Site: www.chronbooks.com.

Type defined the Art Deco exuberance of the twenties and thirties as much as cubistic fashions, streamline furniture, setback skyscrapers, and luxury ocean liners. Fashionable veneers covered clothes, furniture, architecture, and machines, but stylish display type-faces were the seals of modernity. On the printed page, in advertisements for hundreds of contemporary products, modernistic faces conjured up an image of progress. Type designers may not have entered the higher ranks of industry, but they were in the trenches of the consumer revolution between the world wars; their work was highly **INTRODUCTION** valued by business. With the power to influence popular perceptions, new type designs were released with great fanfare.

Type specimen sheets from the mid-1920s through the early1930s were enticing displays of a new commodity. Typefaces were not merely neutral marks communicating ideas or information; they were symbols of the new and the improved. Advertising artists throughout the industrialized world demanded stylish faces with Jazz Age vibrance and modernistic conceit. With the widespread growth of display advertising in the early twentieth century, novel and novelty letter forms — some revivals of historical faces, others contemporary inventions — appealed to printers and designers. Under the broad banner of Modernism, scores of new typefaces (and complimentary ornaments and dingbats) with futuristic names like Vulcan, Metropolis, Modernistic, Cubist Bold, and Novel Gothic heralded the Machine Age.

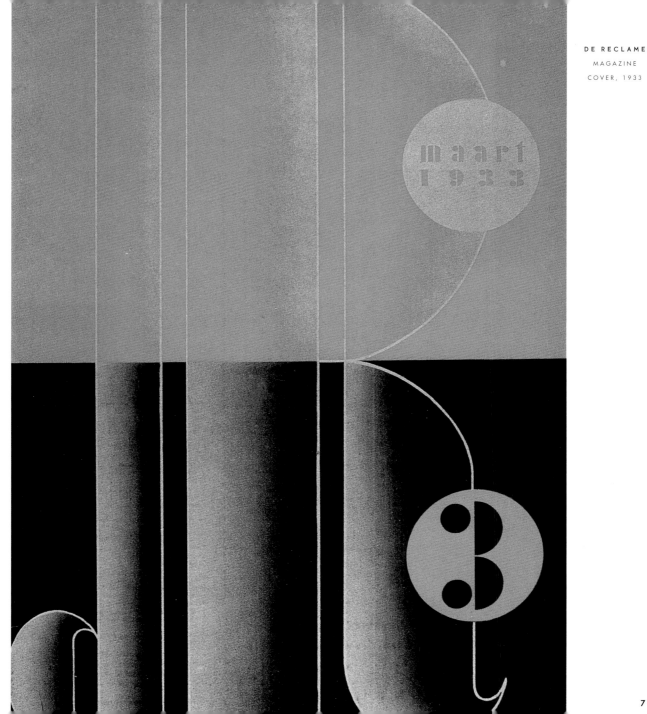

Trade journals of the period claimed that advertising was the spearhead of progress. In truth, progress was a fetish. Timeworn styles were deemed passé simply to clear the way for new products that were reissued in contemporary dress. A modern commercial aura developed, underscored by the graphic marriage of austere avant-garde mannerisms with ostentatious ornament. The sharp edges — the shock of the new — of radical Futurist, Constructivist, and de Stijl design of the early twenties were smoothed out in the latter part of the decade by the addition of stylish decorative devices. In terms of type, Modern sans-serif letters, which some industry critics argued were much too forbidding, were made accessible through shadows, squiggles, and motion lines. With these quirky faces in hand, aggressive typeface distributors perpetuated the myth that modernistic design could move goods swiftly off the selling floor.

This was the era of hawking and pitching, the nascence of salesmanship in burgeoning international markets. Advertising trade magazines like *More Business* and *Printed Salesmanship* in America, *Reklama* in Holland, *Commercial Art* in England, *La Pubblicita* in Italy, *Gebraushgrafik* in Germany, and *Publicité Modial* in France, promoted marketable typeplay. Advertisements and packages were designed with a single goal: to make profit. Modernity was the hook, or the "fatal dart," as A. Tollmer, the French advertising expert, referred to it in *Mise en Page* (The Studio, 1931). Here's how it worked: In an ad or on a package, a typical Art Deco typeface such as Broadway or Streamline announced contemporaneity; the type framed a stage on which anything from boot polish to automobiles was sold. Stylish type was more than a graphic accent on a page or poster; it was the pitchman's most useful prop. And type specimen sheets were the virtual sample cases from which the printers and advertising artists drew their graphic pitches.

The story of Deco type is told through the specimen sheets of the era, many of which are reproduced here. Yet specimens were not new to this period. In the sixteenth century, typefaces were exhibited to printers as partial or complete alphabets, usually displayed in lines of incremental weight as if on a contemporary eye chart. During the

late nineteenth century, samples of metal or wood types were frequently set as quotations from the Bible or litera-ture. If the compositor was an erstwhile poet, he might set lines of personal verse or doggerel. By the turn of the century, type reform movements in Germany and France introduced specimens of Art Nouveau faces, curvilinear hand-lettered forms imbued with all the floriated madness of the period. By the early twentieth century, type found-ing had evolved into a big business with its own unique standards, and contemporary type catalogs, brochures, and specimen sheets were rosters of form and style that guided printers through the intricacies of spacing and leading. Before standard measurements were imposed, printers were prevented from using types from different foundries on the same lines because the lead slugs were not of equal size. Printers usually bought their type fonts from one or two sources; but standardization made cross-purchasing possible, hence creating an even more competitive field.

After World War I, type specimens were designed in jazzier ways. Competing type founders and distributors borrowed many of the marketing tropes from advertisers, whom they serviced, to sell families of type as if they were clothes or cosmetics. "Type is the motive power of advertising; Type is the clothes of an advertisement; Type commands attention and respect," shouted one of the score of hyperbolic American Typefounders Company cata-logs. Specimen sheets further announced the latest fashions in hot metal: "Three Larger Sizes Now Ready," screamed the headline on a brochure for Ultra Bodoni, a garish adaptation of a classic typeface. "A Colorful Showing of Beautiful French Types," read the flyer for a selection of the most recent foreign imports. Like any prod-uct, a typeface was designed to sell. And sell big. Given the resources needed to design and produce type, unpop-ular faces were costly failures.

Covers for type specimens were often as dazzling as a book jacket or sheet-music cover. A tornado of color on the announcement for Ludlow's Ultra-Modern Bold (pages 46–47) was indicative of typical aesthetic hardsell. In the American Typefounders Company "Broadway Series" (pages 36–37) silhouettes dance along the pages. The

specimen for A. M. Cassandre's quintessential Deco typeface, Bifur (page 27), was even more ambitious, with a metallic paper cover and a die-cut circle through which a letter of this wildly eccentric face was revealed. The so-called perfume faces (which were used to advertise sundries and fragrances) employed covers that were rendered with modernistic flourishes and swashes. Inside, however the layouts were more business-like, with sample lines of letters systematically composed according to their relative weights. Sandwiched between these showings were examples of type in two or three bright, flat colors shown in use as advertisements, calendars, flyers, letterheads, and logos.

Deco typefaces were influenced by two intersecting trends: The typographic reform movement known as the New Typography, which was codified by German type master Jan Tschicold in 1925, and the decorative practice of the late nineteenth-century, which was influenced by bold poster lettering. The former was a rejection of anti-quated nineteenth century rules of composition that had been grandfathered by craftsmen who slavishly followed traditional formulas. The latter, which was an update of commercial job-printing techniques void of any philosophi-cal rationale. The New Typography was the synthesis of typographic experimentation conducted in the 1920s by avant-garde artists in Russia (Constructivism), Italy (Futurism), and Germany (at the Bauhaus); an orthodoxy char-acterized by sans-serif faces, the rejection of ornament, and asymmetrical composition. The decorative approach was simply a modernization of the prevailing fashion for novelty letter forms used in everyday printing; the only thing revolutionary about it was that some critics thought these faces were revolting.

In the purest sense, Modern typography of the '20s and '30s is rooted in the rightness of certain basic forms: the circularity of a circle, the squareness of a square. "It revolted against the flabby sentimentalist, the weaver of legends, the exponent of meaningless platitudes," wrote Faber Birren in *The American Printer* (April 1929). Modern typography further reflected the tempo of modern times — speed. The feeling of movement, as expressed through asymmetric arrangement of lines and type, was a way to attain a rhythm that guided the reader's eye to

the message. "The center of gravity of the asymmetric arrangement," wrote Douglas C. McMurtrie in *Modern Typography and Layout* (Eyencourt Press, 1929), "is that of a man running; if the movement is halted, the man falls; if the asymmetric type layout leads the eye to a point of rest, instead of insistently carrying it onward until its intended course is run, the whole composition collapses."

The New Typography was embraced more enthusiastically in Europe, where it began, than in the United States, where progressive design arrived late. European publicity focused on the image; American advertising revered the word. European advertising was rooted in Modern Art; American illustration was sentimental and romantic. Europeans were quicker to accept new marketing ideas to promote their burgeoning consumer culture. Conversely, before accepting avant gardisms, suspicious American advertising managers demanded assurances of the viability of European methods on American consumers. Regarding the appropriateness of type, the prevailing opinion was, as one printer put it in 1928, "the only type that is worth a tinker's dam is the kind that causes Mr. Average Man to dig into his pocket, or Mrs. Average Woman to sign her check...." However, when American printers and typographers finally acknowledged Modernism's utility as a selling tool, they were often split over how it should be practiced. "Modernistic typography is by no means an affair of embellishment and fanciful adorn-ment," added Birren. "In modernistic typography it is best to avoid cursive types, printer's flowers [dingbats] and decorative initials." Ornament was rejected by some who accepted the letter of the Modern law, while accepted by others when, as the brochure for the Thomas P. Henry Company, a printer in Detroit, Michigan, said, it "fit the thought [of the ad] to a T."

"'Modernism'... got off on the wrong foot in America," asserted advertising and industrial designer Walter Dorwin Teague in *Advertising Arts* (1931). "It had been developing as a school of design for many years in Europe, outgrowing its absurdities and cutting its wisdom teeth. But it burst on America as a full-fledged surprise, and we've never quite recovered from the shock." Real Modern design was, "too severe for those [printers] who

have never really learned to create a design," wrote Robert McCay in *The American Printer* (October 1929). He argued that the average practitioner had "been brought up on the bread and milk of adapting or lifting some Italian or French decoration.... As a result, we, the designers of America, have been caught unprepared by this movement in which no ready made motif will suffice."

Deco type was born out of the need to be modern and, at the same time, to retain certain traditional values. "Modernism in typography, unfortunately, lends itself readily to the derivation of unintelligent formulas," chided McMurtrie. The concept of "going modern" in the advertising industry signified "an axis off the center of the layout, with sans-serif types in square blocks disposed to the right or the left of this axis," he added. In otherwords, a layout can be made to look modern by an agglomeration of unrelated, symbolically modern elements. This did not mean it was Modern, but such layouts were moderne.

The "e" at the end of the word *modern* signified the commercially stylistic manifestations of the Modern method, and today *moderne* serves to categorize the majority of the typefaces designed for fashion-conscious designers of the twenties and early thirties. Today, none of these faces are really classic; although a few, like Broadway, Boul Mich, and Peignot, are still used to evoke the Deco aura. None are sacred icons of the New Typography, either; but these are the artifacts of typographic extravagance. Whatever crimes of aesthetics might have been perpetuated in the name of modernity, many of the novel and novelty typefaces had a unique charm and, more important, they were eyecatching on advertisements, posters, and packages.

"It is only the modern that ever becomes old-fashioned," wrote Oscar Wilde. And so the archetypal moderne types eventually ossified into period pieces. By the thirties, the majority of the world was suffering through economic depression, and advertising no longer could be what the magazine *Advertising Arts* called "effete." In America and Europe, "shirt sleeve" advertising replaced ultra-stylish mannerisms. Functional typography was swapped for decorative design. "Type is becoming simpler every day," wrote Harry T. Batten, vice president of N.W. Ayer, in

Modern Publicity (1931), deriding what he labelled "the modernistic movement" of 1929, which often failed to realize that "advertising is primarily to be read." In the mid-thirties, layouts were inclined to be economical: "There was a noticeable lack of fussy ornament, an increasing cleanness and crispness of line.... Fewer rules and type ornaments were used than in the first flush of 'Modernism,'" added Batten. This new phase of American Modern graphic design is what Frederic Ehrlich referred to as "a return to typographic sanity," and "a glorious sunrise [that] dispelled the cold gray sky that overshadowed the real modernism in typography...." He prophetically added: "If, or when Post Modernism appears to take the place of the Modern Typography, it cannot fail to incorporate the salient features of what we now know as modern."

When the novelty wore off by the mid-thirties, specimen sheets also reverted to being more functional. Design inspiration came in showings of dingbats, sectional dashes, and other printers' "jewels." In Bauersch Giesserei's "Futura Schumck" (pages 90–91), the equivalent of a child's set of blocks, a litany of geometric forms is used to construct abstract and representational images for the Modern layout. The sheet for ATF's Cubistic dingbats (page 49), which includes an array of stair-step and sawtooth ornaments printed in bright pastels, seems contemporary by today's standards. With austerity imposed on the advertising business, the breaks were put on extravagant type promotion. Most type foundries — American Type Foundry Company, Deberny & Peignot, Bauer, Stempel, and others — continued to issue samples, but notices of new designs lacked fanfare.

Along with cubistic fashions, streamline furniture, setback skyscrapers, and luxury ocean liners, the production of Deco types ceased during the forties. The era of Machine Age invention and consumer vitality vanished into history. Yet in recent years, some of the most distinctive Deco types have been revived and reissued. This should not be ascribed to nostalgia alone, for they continue evoke a time that has captured the romantic imagination.

Paris was the birthplace of moderne design, and so the wellspring of Deco type. Innovations in French typography were born in advertising, particularly through posters, where the letter, as *affichiste* A. M. Cassandre wrote, "is really the leading actor." Freehand letterforms designed to compliment the modernistic illustrations on these posters were the basis for a variety of hot metal alphabets produced by Deberny & Peignot, Paris's leading foundry and purveyor of typography. This was the period when designers and illustrators, who were not necessarily trained typographers, contributed a huge **FRANCE** number of popular commercial alphabets. Since the days of the master type makers Fournier and Didot, French type design was known for its elegance. By the twenties it also was celebrated for its chic. French faces defined the opulent Deco era, and types with names like Parisian, Éclair, Bifur, and Peignot were among France's major exports (particularly to America). French designers were masters of decoration, and many of the novel faces and hand-drawn letters were wildly ornate. The sawtooth rules, sunbursts, and lightning bolts that characterized moderne styling were integrated into the quirkiest alphabets. Stencil-like letters with sharp edges were all the rage. Many of these were designed for the moment, and few of these eccentricities remained in currency for more than a few years. Nevertheless, a face like Bifur, Cassandre's most exotic, has become a classic example of twentieth century typographic invention.

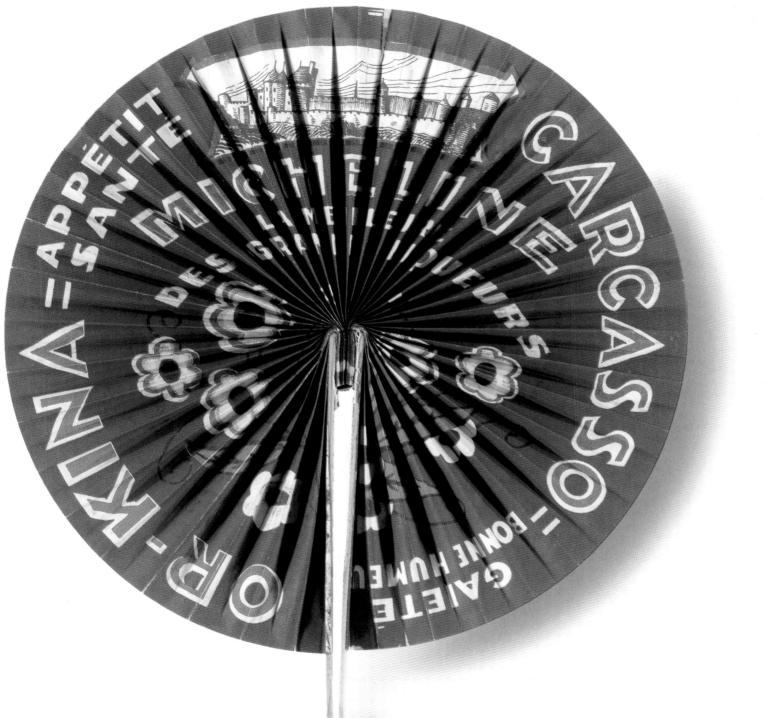

ABCDEFGHI
JKLMNOPQ
RSTUVXYZ

UNTITLED

ALPHABET, 1928

DESIGNER: DRAIM

FROM *LA LETTRE ARTISTIQUE AND MODERNE*

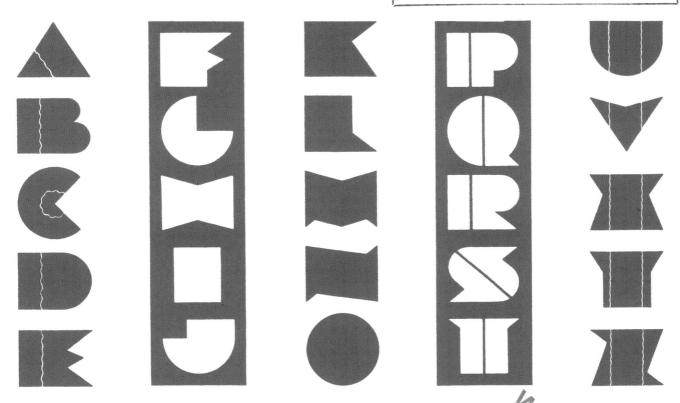

UNTITLED
ALPHABET, 1923
DESIGNER: DRAIM
FROM *LA LETTRE ARTISTIQUE AND MODERNE*

17

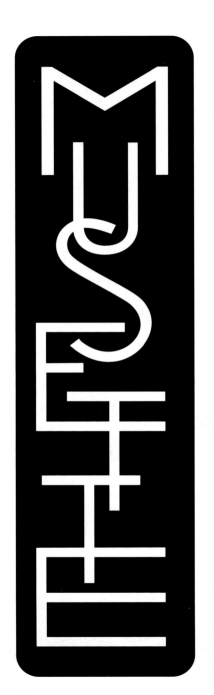

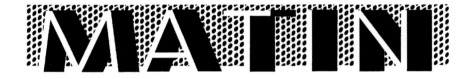

BLUETS

MATIN

CONCERTS

L'ACIER GRIS

BERNARD

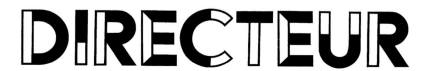

DIRECTEUR

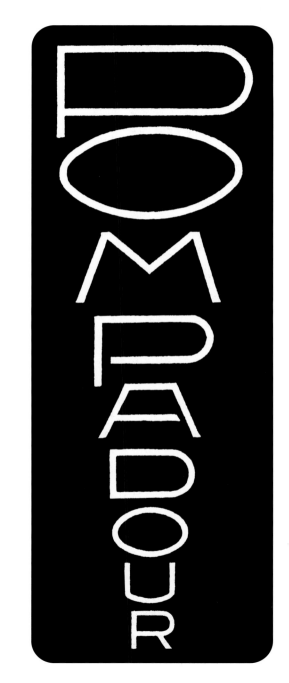

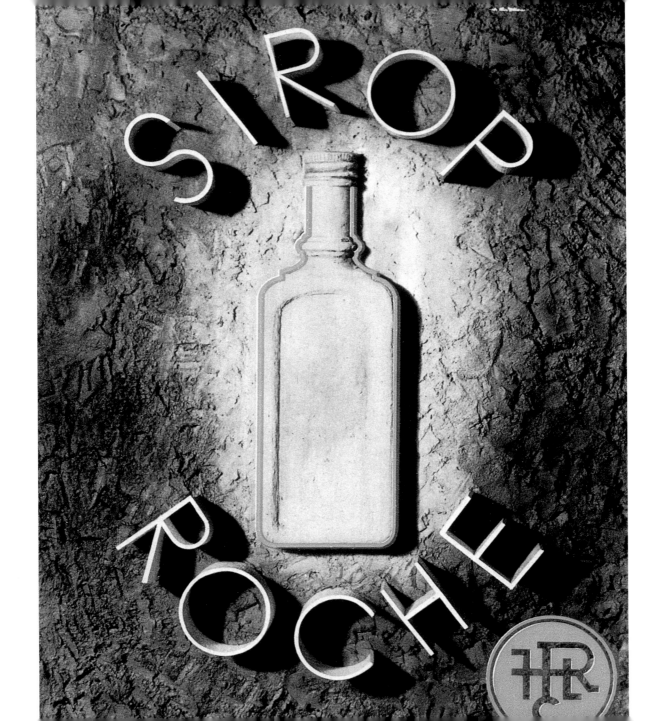

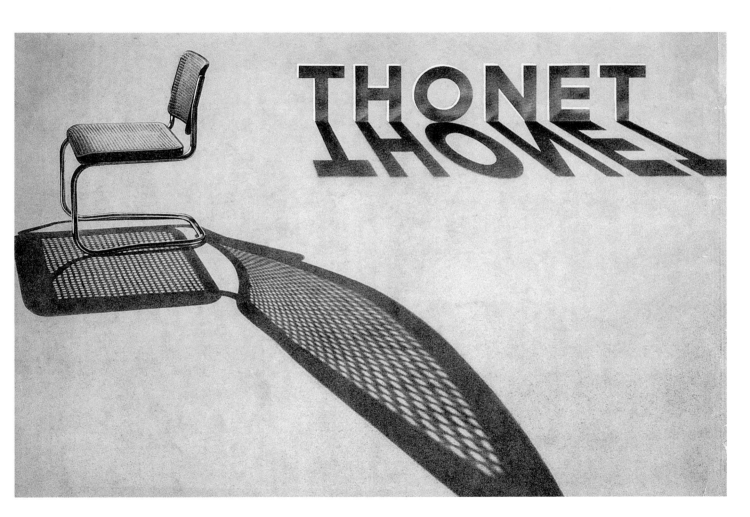

THONET

CATALOG COVER WITH

DIMENSIONAL LETTERS, 1929

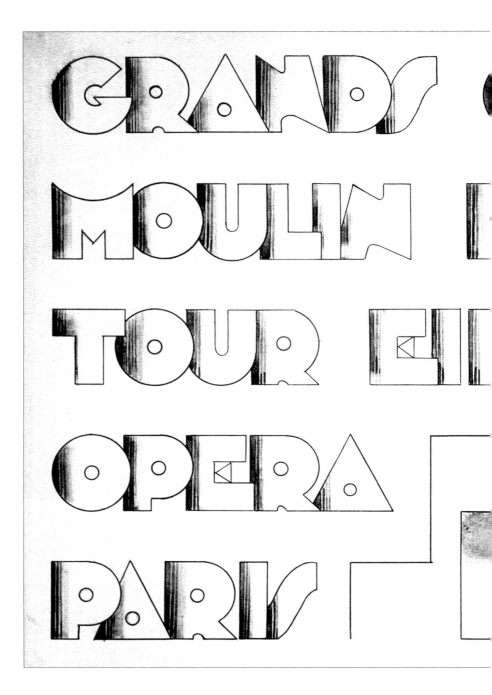

GRANDS

MOULIN

TOUR EI

OPERA

PARIS

22

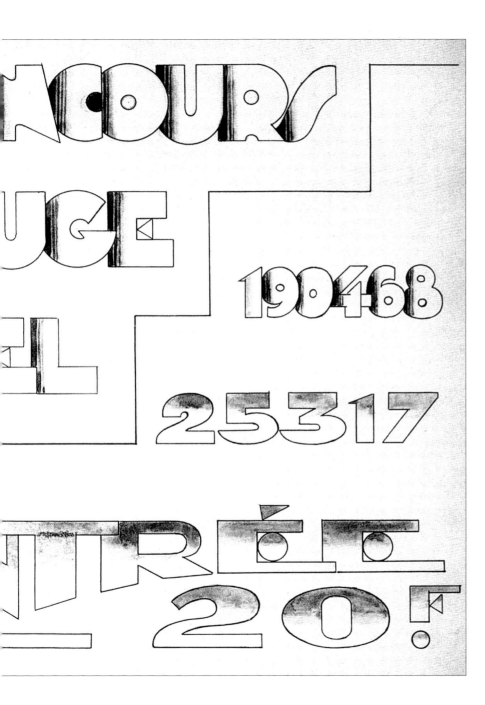

UNTITLED
TYPE SPECIMEN, 1931
DESIGNER: A. BARDI
ÉDITIONS GUÉRINET

AFFICHES PANCARTES ?
UN CARACTÈRE DE PUBLICITÉ DOIT ACCROCHER LE REGARD ! UN CARACTÈRE BIEN LISIBLE

l'Indépendant reste inégalable

Seul l'Indépendant est le caractère qui donne toujours satisfaction à vos clients

L'Art Graphique en 1930

Publicité moderne !

Les annonces et les réclames.

INDEPENDANT
TYPE SAMPLE, 1930
DESIGNERS: G. COLLETTE AND J. DUFOUR

BIFUR

ALPHABET, 1929

DESIGNER: A. M. CASSANDRE

MONOTYPE COMPOSITION COMPANY

BIFUR

ADVERTISEMENT, 1930

DESIGNER: A. M. CASSANDRE

DEBERNY AND PEIGNOT

BIFUR
CARACTÈRE DE PUBLICITÉ CARACTÈ
RE DE PUBLICITÉ CARACTÈRE DE PU
BLICITÉ CARACTÈRE DE PUBLICITÉ
CARACTÈRE DE PUBLICITÉ CARACTÈ
RE DE PUBLICITÉ CARACTÈRE DE PU
BLICITÉ CARACTÈRE DE PUBLICITÉ
CARACTÈRE DE PUBLICITÉ CARACTÈ
RE DE PUBLICITÉ CARACTÈRE DE PU
BLICITÉ CARACTÈRE DE PUBLICITÉ
CARACTÈRE DE PUBLICITÉ CARACTÈ
RE DE PUBLICITÉ CARACTÈRE DE PU
BLICITÉ CARACTÈRE DE PUBLICITÉ

BIFUR

ÉDITÉ ET FONDU PAR LES FONDERIES

DEBERNY ET **PEIGNOT**

18, RUE FERRUS

PARIS

ABCDEF
GHIJKL
MNOPQR
STUVXY
ISÆŒWƉ
Cᴵᵉ .,:;-'?!()«»Ç
1234567890

BUT

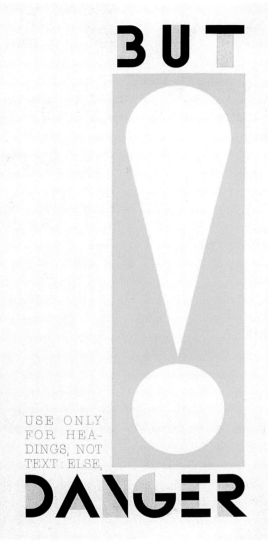

USE ONLY
FOR HEA-
DINGS, NOT
TEXT : ELSE,

DANGER

THIS IS NOT THE WAY TO USE BI
FUR THIS IS NOT THE WAY TO USE
BIFUR THIS IS NOT THE WAY TO
USE BIFUR THIS IS NOT THE WAY
TO USE BIFUR THIS IS NOT THE
WAY TO USE BIFUR THIS IS NOT
THE WAY TO USE BIFUR THIS IS
NOT THE WAY TO USE BIFUR THIS
IS NOT THE WAY TO USE BIFUR
THIS IS NOT THE WAY TO USE BI
FUR THIS IS NOT THE WAY TO USE
BIFUR THIS IS NOT THE WAY TO
USE BIFUR THIS IS NOT THE WAY
TO USE BIFUR THIS IS NOT THE
WAY TO USE BIFUR THIS IS NOT
THE WAY TO USE BIFUR THIS IS
NOT THE WAY TO USE BIFUR THIS
IS NOT THE WAY TO USE BIFUR
THIS IS NOT THE WAY TO USE BI
FUR THIS IS NOT THE WAY TO USE
BIFUR THIS IS NOT THE WAY TO
USE BIFUR THIS IS NOT THE WAY
TO USE BIFUR THIS IS NOT THE
WAY TO USE BIFUR THIS IS NOT
THE WAY TO USE BIFUR THIS IS
NOT THE WAY TO USE BIFUR THIS
IS NOT THE WAY TO USE BIFUR
THIS IS NOT THE WAY TO USE BI

BIFUR

TYPE SPECIMEN, 1929

DESIGNER: A. M. CASSANDRE

MONOTYPE COMPOSITION COMPANY

American type design of the twenties and thirties often celebrated sobriety. "A good piece of modern typography is fairly simple and sane," wrote Edmund G. Gress in *Fashions in American Typography*. "Contemporary type design," echoed Frederic Ehrlich in *The New Typography and Modern Layouts*, "is devoted to simplicity and sanity." Modernism was a rejection of the stranglehold of tradition as well as of the pervasive ad hocism in type and layout design. But Modernism was not just a sensible means of presenting information. It offered what Jackson Lears, in *Fables of Abundance,* **AMERICA** called the "aura of cosmopolitan culture and avant-garde style," yet Modern graphics were often harshly received by design critics as stylistic mannerisms, with good reason. To keep up with both the fashions of the time and their competitors, type designers prostrated themselves to create the most contemporary letterforms at the expense of typographic standards. Ehrlich, a harsh critic of modernistic intemperance, denounced the decorative excesses in type, layout, and ornament—the reflexive zeal to be modern—as "dynamic indigestion...unreasoned and riotous composition...the revolts of rebellions through which modernism had passed or was a part of." Many deco letterforms fell into what Ehrlich referred to as "monstrous" for their total disregard of accepted tenets. Paradoxically, it was this rejection that made the eccentric types compelling, if only for the moment.

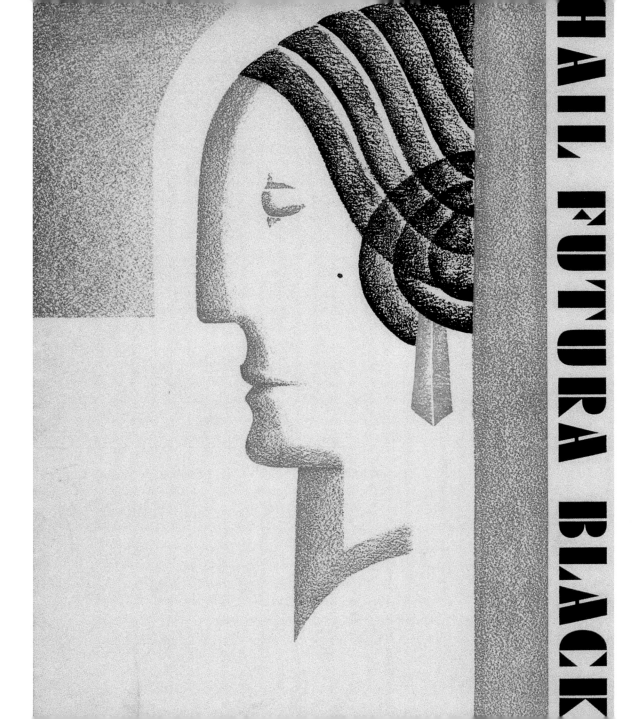

HAIL FUTURA BLACK

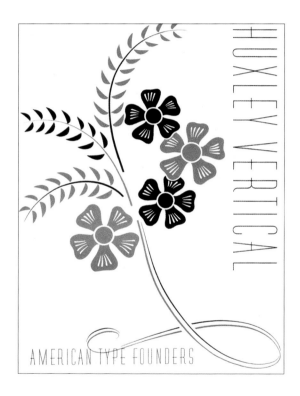

HUXLEY VERTICAL

SPECIMEN SHEET COVER, 1936

DESIGNER: WALTER HUXLEY

AMERICAN TYPE FOUNDERS COMPANY

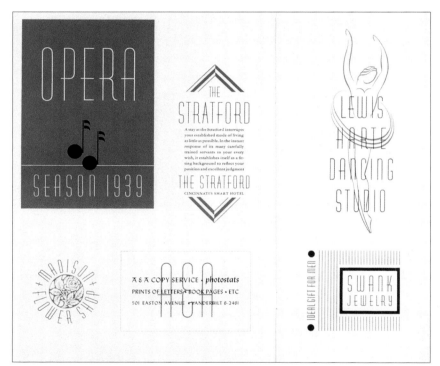

HUXLEY VERTICAL

TYPE SAMPLES, 1936

DESIGNER: WALTER HUXLEY

AMERICAN TYPE FOUNDERS COMPANY

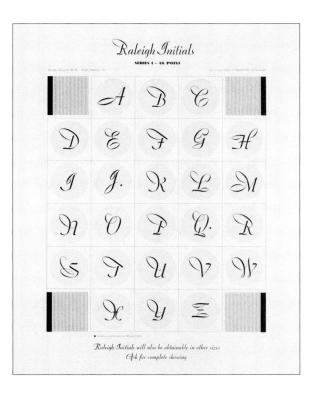

RALEIGH INITIALS
SPECIMEN SHEET, C. 1927
AMERICAN TYPE FOUNDERS COMPANY

RALEIGH CURSIVE AND MODERNIQUE
TYPE SAMPLE, C. 1927
AMERICAN TYPE FOUNDERS COMPANY

TWO-SERIES *Typography*

Raleigh Cursive

and

MODERNIQUE

Shown in

Combination

Modern
Type Faces are created
primarily to attract the
attention and to hold the
eye of the general reader.
We are living in a fast-
moving age and catering
to the most exacting and
discriminating people in
the history of the World

ABCDEF
GHIJKLM
NOPQRS
TUWXYZ
abedefghi
klmprstuw

COTY

SAMPLE OF HAND LETTERING, 1930

DESIGNER J. R. MCKINNEY

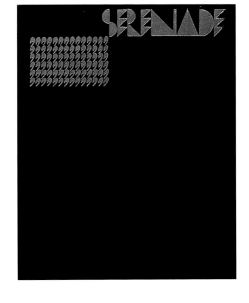

SERENADE

BOOK COVER LETTERING, 1932

DESIGNER: W. A. DWIGGINS

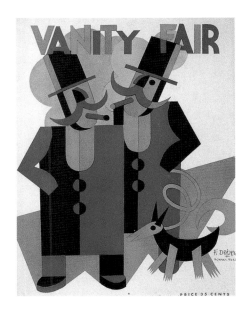

VANITY FAIR

MAGAZINE LOGO LETTERING, 1931

DESIGNER: FORTUNATO DEPERO

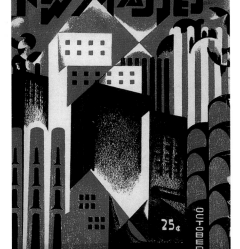

NEW MASSES

MAGAZINE LOGO LETTERING, 1926

DESIGNER: LOUIS LOZOWICK

MODERNISTIC SERIES
SPECIMEN SHEET, 1927
DESIGNER: WADSWORTH A. PARKER
AMERICAN TYPE FOUNDERS
COMPANY

PAYMENT

60 Point

UNBELTING

48 Point

ENSIGN

36 Point

GRACIOUS

30 Point

DISTINGUISH

24 Point

SPECIAL SALES
FINE GOWN

18 Point

HANDMADE LINGERIE
SILK NECKWEAR

Characters in Complete Font

A B C D E
F G H I J K
L M N O P
Q R S T U V
W X Y Z & $
1 2 3 4 5
6 7 8 9 0

34

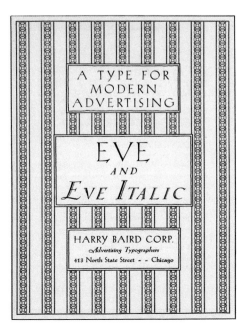

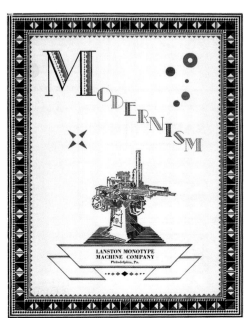

BALLÉ INITIALS

TYPE SAMPLE, C. 1930

DESIGNER: MARIA BALLÉ

BAUER TYPOGRAPHIC SERVICE

EVE AND EVE ITALIC

TYPE SPECIMEN COVER, 1928

DESIGNER: RUDOLF KOCH

HARRY BAIRD CORPORATION

MODERNISM

TYPE SPECIMEN COVER, 1927

LANSTON MONOTYPE COMPANY

THE BROADWAY SERIES

NOW READY FOR PRINTERS IN SIZES FROM 12 TO 48 POINT

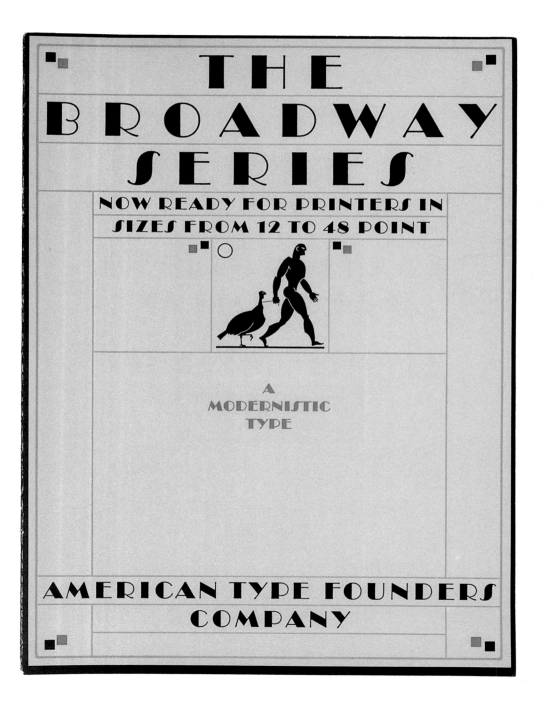

A
MODERNISTIC
TYPE

AMERICAN TYPE FOUNDERS COMPANY

BROADWAY SERIES

48 Point · 3A $9 80

NEW MODEL HOSIERY

36 Point · 5A $7 90

DRESSES DIRECT FROM PARIS

30 Point · 6A $6 60

STYLISH IMPORTED VELOUR HATS

24 Point · 8A $5 20

POTTERY
BRASS BED
PIANO

14 Point · 13A $3 70

FINE JEWELRY
FRENCH CABINET
MUSIC
WALLPAPER

18 Point · 10A $4 20

BEAUTIFUL
CHINESE RUGS
LINOLEUM

12 Point · 14A $3 20

ANTIQUE CLOCK
BROCADED CURTAIN
STATUARY
EVENING WRAP

THE BROADWAY SERIES
TYPE SPECIMENS, 1929
DESIGNER: MORRIS FULLER BENTON
AMERICAN TYPE FOUNDERS COMPANY

MODERN

Modern type faces are created primarily to attract the attention and hold the eye of the general reader We are living in a fast moving age and catering to the most exacting and discriminating people in the history of the world *Modern advertisers fully appreciate the importance of the new movement* They understand its progress. Old styles of type display are outmoded, and advertising has gained in effectiveness

American Type is Strictly Modern

RIVOLI ITALIC
TYPE SAMPLE, 1929
DESIGNER: WILLARD T. SNIFFIN
AMERICAN TYPE FOUNDERS COMPANY

GA

72 Point

MODERNI

60 Point

PRIZE DESI

48 Point

BUSINE∫∫ CON

36 Point 6A $10.00

MAGAZINE
NEW LAYOUT
∫KETCH

A A
F G
N O
∫ ∫
V W
1 2 3

12 Point 16A $4.00

COMPOSITORS CAN OBTAIN
BEAUTIFUL EFFECTS WITH
THI∫ INTERESTING TYPE

18 Point 12A $5.25

ADVERTISING MAN
INTERESTED IN ARTISTIC
TYPOGRAPHY

AMERICAN TYP

IC TYPES

SELECTED

IONS ACTIVE

3A $21.00

3A $14.75

4A $11.50

30 Point

**NUMEROUS
IMPROVEMENTS
PLANNED**

8A $8.50

14 Point

**A NOVELTY TYPE FACE
FOR THE PRINTER OF
HIGH~CLASS JOB WORK**

15A $4.25

24 Point

**MORRISON'S
REGULAR SERVICE
CONTINUED**

9A $6.50

NDERS COMPANY

E E
L M
R S
T U
& S
8 9 0
! ?

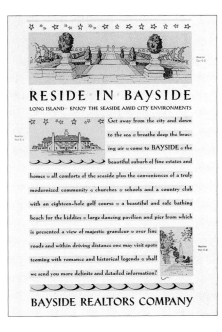

RESIDE IN BAYSIDE

LONG ISLAND · ENJOY THE SEASIDE AMID CITY ENVIRONMENTS

Get away from the city and down to the sea ✿ breathe deep the bracing air ✿ come to BAYSIDE ✿ the beautiful suburb of fine estates and homes ✿ all comforts of the seaside plus the conveniences of a truly modernized community ✿ churches ✿ schools and a country club with an eighteen-hole golf course ✿ a beautiful and safe bathing beach for the kiddies ✿ large dancing pavilion and pier from which is presented a view of majestic grandeur ✿ over fine roads and within driving distance one may visit spots teeming with romance and historical legends ✿ shall we send you more definite and detailed information?

BAYSIDE REALTORS COMPANY

PARAMOUNT
TYPE SAMPLE, 1928
AMERICAN TYPE FOUNDERS COMPANY

GALLIA SERIES
TYPE SPECIMEN, 1927
DESIGNER: WADSWORTH A. PARKER
AMERICAN TYPE FOUNDERS COMPANY

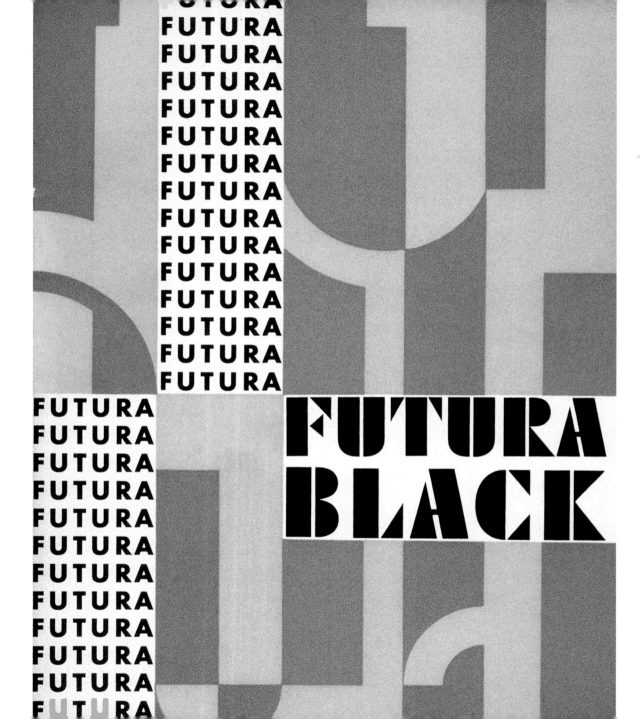

FUTURA
FUTURA
FUTURA
FUTURA
FUTURA
FUTURA
FUTURA
FUTURA
FUTURA
FUTURA
FUTURA
FUTURA
FUTURA
FUTURA
FUTURA
FUTURA

FUTURA
FUTURA
FUTURA
FUTURA
FUTURA
FUTURA
FUTURA
FUTURA
FUTURA
FUTURA
FUTURA
FUTURA

FUTURA
BLACK

FUTURA BLACK · A NEW

DESIGN BY PAUL RENNER

20 Point 9 A 17 a

MECHANICAL ART OF PRINTING
Originality of design in showings

24 Point 8 A 15 a

POPULAR INDIAN MELODIES
For sale on Washington Street

30 Point 6 A 12 a

ADVERTISING AGENCY
With gifts unique and rare

36 Point 5 A 10 a

THE BEST READING
Woolworth Building

48 Point 5 A 9 a

AUTOMOBILES
Provincial Bank

60 Point 5 A 8 a

RESIDENCE
Music House

72·60 Point 4 A 6 a

DISPATCH
Charleston

84·72 Point 3 A 4 a

EDITION
Hamilton

FUTURA · THE TYPE OF

TODAY AND TOMORROW

(OPPOSITE)

FUTURA BLACK

TYPE SPECIMEN COVER, C. 1930

DESIGNER: PAUL RENNER

BAUER TYPE FOUNDRY, INC.

FUTURA BLACK

TYPE SPECIMEN COVER, C. 1930

DESIGNER: PAUL RENNER

BAUER TYPE FOUNDRY, INC.

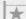

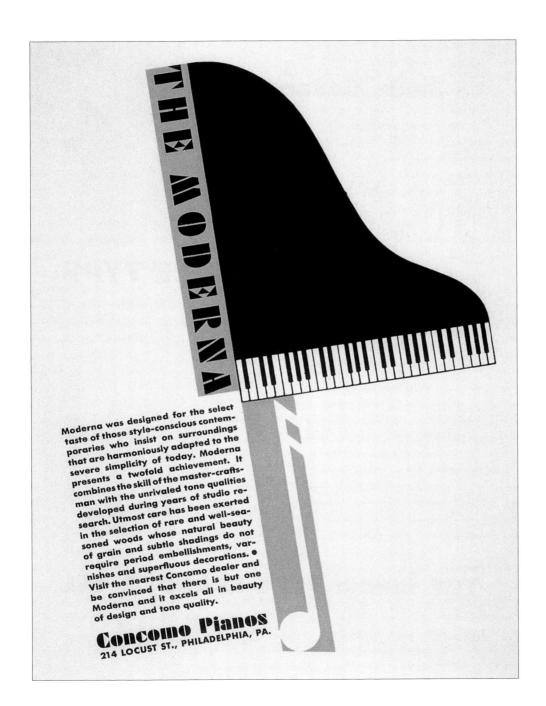

FUTURA BLACK
TYPE SAMPLE, C. 1930
DESIGNER: PAUL RENNER
BAUER TYPE FOUNDRY, INC.

ABCDEFGHIJKL
MNOPQRSTUVWX
YZ°I23456789?

ABCDEFGHIJKL
MNOPQRSTUVW
XYZ*123456789

UNTITLED
ALPHABETS, 1938
DESIGNERS: PAUL CARLYLE AND GUY ORING

ABCDEFGHIJKL
MNOPQRSTUVW
XYZ·123456789

ABCDEFGHIJKL
MNOPQRSTUVW
XYZ*123456789

44

ABCDE
FGHIJK
LMNOP
QRSTU
VWXYZ
1234567890

ABCDE
FGHIJK
LMNOP
QRSTU
VWXYZ
1234567890

UNTITLED
NOVELTY ALPHABETS, 1935
DESIGNERS: W. BEN HUNT AND ED C. HUNT

ABCDE
FGHIJK
LMNOP
QRSTU
VWXYZ
1234567890

ABCDE
FGHIJK
LMNOP
QRSTU
VWXYZ
1234567890

We present in this pamphlet a number of attractive series of type faces designed especially to meet the needs of the advertiser who requires that his publicity printing be presented to the public in the vivid modernistic style so much in vogue at present

It is a conceded fact that the printing office which is provided with half a dozen or more of the modern type designs is sure to be favored with the very choicest and most profitable orders

American Type Founders Company

BROADWAY SERIES

DINE

SHOW

RIDING

GARDEN

ENTICING

POSTPONES
FIRST RACE

RAPID STRIDE
FRENCH BANK

CHARACTERS IN FONT

A B C D E F
G H I J K L
M N O P Q R
S S S T U V
W X Y Z & $
1 2 3 4 5
6 7 8 9 0
. , - ' : : ! ?

REAL BARGAIN
SUMMER WEAR

BETTER SHOWING
UNUSUAL PLACES

MODERN RECEPTION
DELIGHTFUL SINGER

STYLISH BUSINESS SUITS
PLAIN SCOTCH WORSTED

GREAT SYMPHONY ORCHESTRA
RECOGNIZED MUSICAL GENIUS

PICTURESQUE MASQUERADE COSTUMES
ENACTS WONDERFUL MOUNTAIN SCENE

PRICES AND SCHEMES OF JOB FONTS

6 Point 20A $2.10	10 Point 17A $2.90	18 Point 10A $4.20	36 Point 5A $7.90	60 Point 3A $14.85
8 Point 19A 2.60	12 Point 14A 3.20	24 Point 8A 5.20	42 Point 4A 8.90	72 Point 3A 19.70
	14 Point 13A 3.70	30 Point 6A 6.60	48 Point 3A 9.80	

LUDLOW

ULTRA-MODERN BOLD

Number 22-B

47

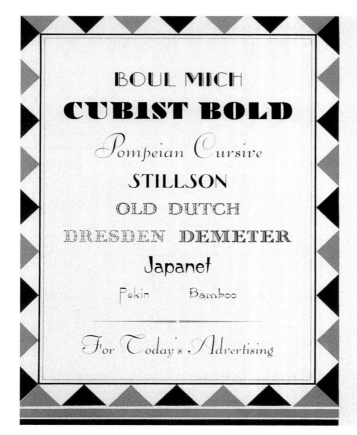

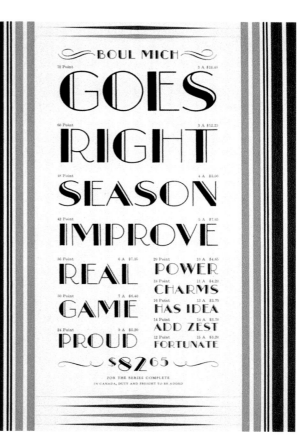

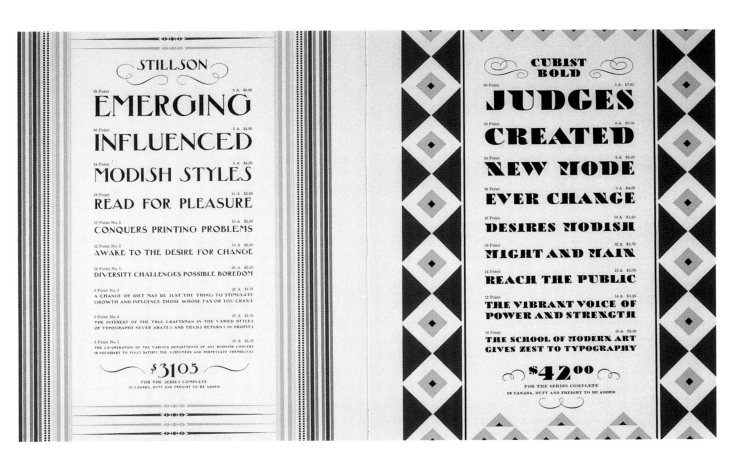

STILLSON (LEFT) AND **CUBIST BOLD** (RIGHT)

TYPE SPECIMENS, 1929

DESIGNER: JOHN ZIMMERMANN

BARNHARD BROS AND SPINDLER

Holland is recognized for both exquisite type design and radical experiments in Modern typography. But in the moderne arena only one leader emerged, *Wendingen*, a Modern arts and architecture magazine that introduced a typographic style that was uniquely Dutch — and quixotically modern. The *Wendingen* style of typography was an outgrowth of Art Nouveau, but it rejected the curvilinear excesses. Instead, this decidedly ornamental approach was severely rectilinear. Although *Wendingen*'s typography was not simplified enough for the proponents of Dutch Modernism, **HOLLAND** it was the model for the less ideological purist practitioners and influenced an entire "school" of commercial designers. *Wendingen*'s large square cover was also an outlet for typographic experimentation, a place for artists and designers to play with odd arrangements and designs of letterforms from Constructivism to art moderne. In addition to a pronounced French influence, the Dutch variant of Deco type was also informed by de Stijl, the avant-garde art movement that sparked a shift from romanticism to objectivity in art rooted in geometry and proscribed by primary colors. De Stijl typography was so rigidly geometric that letterforms looked as though they were built out of letterpress "furniture" (the pieces of lead used to separate lines of type). The more commercial adaptations of this motif, promoted through trade advertising magazines like *Reklama*, were not as severely rectilinear, but were nevertheless more austere than most Deco types.

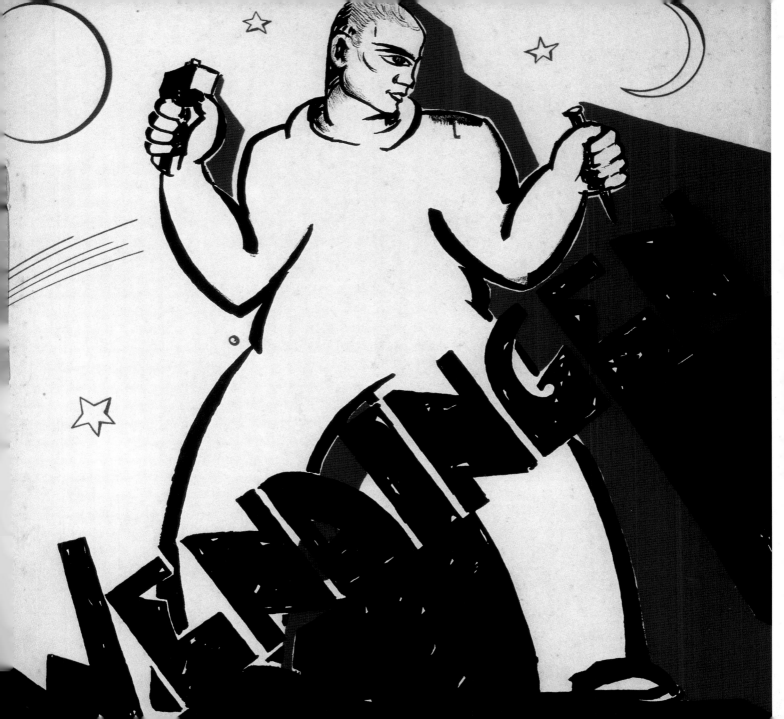

(PREVIOUS PAGE)

WENDINGEN
MAGAZINE COVER, 1931
WITH HAND LETTERING
DESIGNER: H. L. KROP

MOLLERS
LOGO, 1927

LICONA
LOGO, 1926

HONDERDSTE
BROCHURE COVER, C. 1928

NIEMEYERS
LOGO, 1924

THÉÂTRE MODERNE
LOGO, 1926

SPORTING
LOGO, 1924

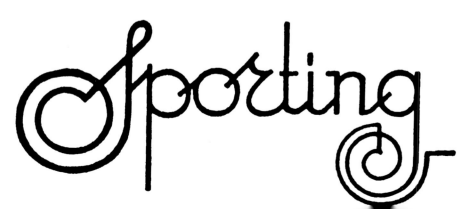

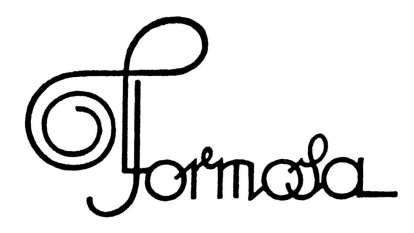

FOTOLUX
LOGO, 1924

PARLOPHONE
LOGO, 1925

FORMOSA
LOGO, 1924

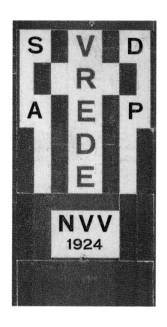

NVV

THEATER TICKET, 1924

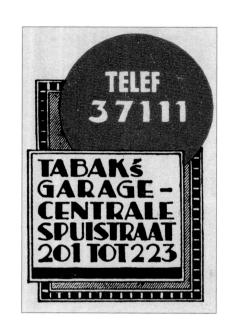

TABAKS GARAGE

LETTERHEAD, 1934

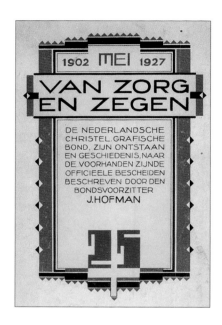

VAN ZORG EN ZEGEN

PRINTING CATALOG COVER, 1927

(OPPOSITE)

PROGRAMMA

MUSIC PROGRAM, 1923

PROGRAMMA

ONZE STER „OLYMPIA"

Olympia, gij zijt een voedster
Van mannenkracht en mannendeugd;
Voor wat ontaardt, verslapt, behoedster,
Een warme haard van levensvreugd.
Gij zijt de ster met schoone glansen,
Die ons den weg naar 't goede wijst.
Uw zinnebeeld zal men bekransen,
Terwijl men ons om 't volgen prijst.
 Olympia! Olympia!
Wij eeren U, hoe 't ons ook ga.

Wij, die ons achter 't vaandel schaarden
Van onze ster Olympia,
Getuigen, hoe wij fluks ontwaarden:
Het eed'le turnen loont weldra.
De bloedpols klopt met forscher slagen;
De spier geeft meer in korter tijd;
De wil leert rustig tucht verdragen;
Naast zelfbedwang groeit moed, beleid.
 Olympia! Olympia!
Wij eeren U, hoe 't ons ook ga.

Het samenbrengen onzer krachten,
Gaf glorie der Vereeniging;
Wij willen zijn de trouwe wachten
En vormen een gesloten kring.
Daar binnen zal het vaandel prijken,
Het oude vaandel met de ster;
Die zal aan glansen steeds verrijken,
Haar stralen schieten tot zeer ver.
 Olympia! Olympia!
Wij eeren U, hoe 't ons ook ga.

A. Staalman

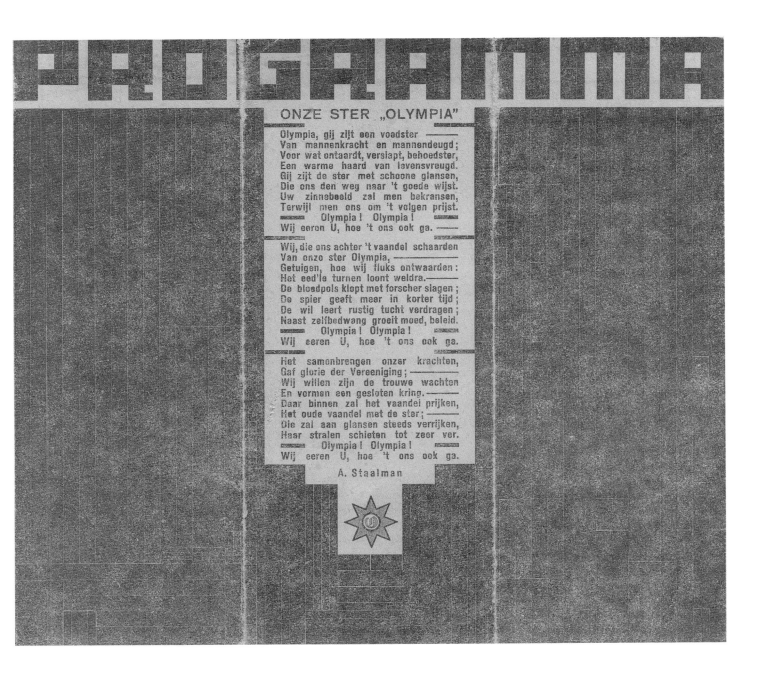

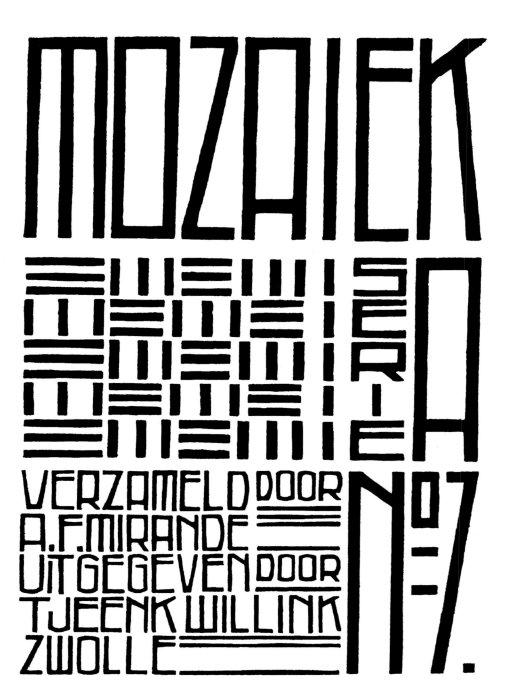

MOZAIEK
JOURNAL COVER, C. 1926
DESIGNER: CATO

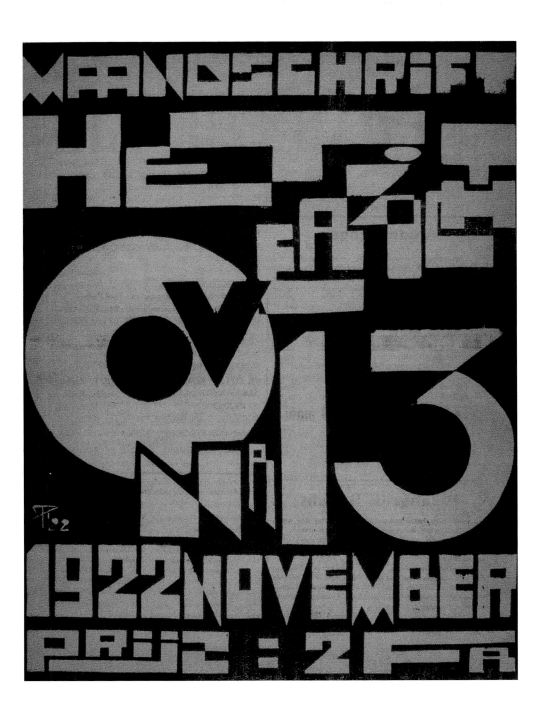

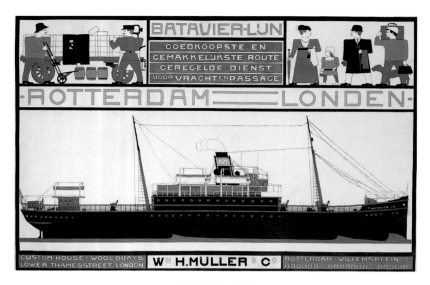

WENDINGEN

MAGAZINE COVER, 1928

DESIGNER: W. H. GISPEN

BATAVIER-LIJN

POSTER, C. 1915

DESIGNER: BART VAN DER LECK

WENDINGEN

MAGAZINE COVER, 1929

DESIGNER: VILMOS HUSZAR

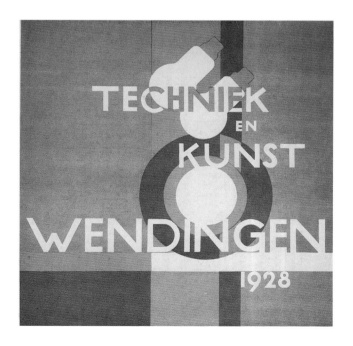

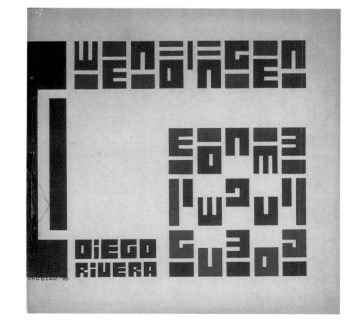

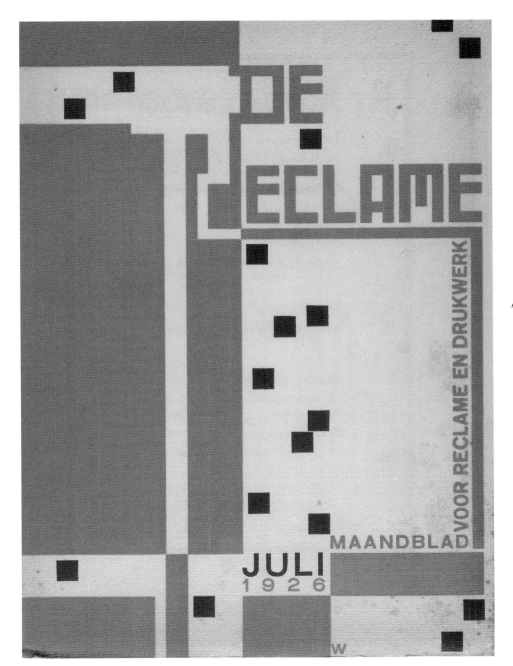

DE RECLAME
MAGAZINE COVER, 1926

ABCDEFGHI
JKLMNOPQ
RSTUVWX?
YZ.Theems.&,!
HUUR·VORM
MAATSCHA
abcdefghijklmn
opqrstuvwxyz..

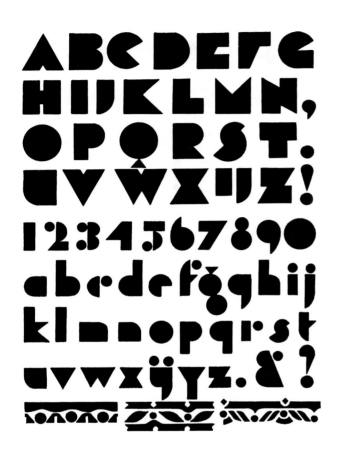

ABCDEFG
HIJKLMN,
OPQRST.
UVWXIJZ!
1234567890
abcdefghij
klmnopqrst
uvwxijyz.&?

UNTITLED
ALPHABET, 1928
DESIGNER: ANDRÉ VLAANDEREN
KOSMOS, AMSTERDAM

ABCDEFGHIJ,
KLMNOPQRS!
TUVWXYZ.&?
abcdefghijklmnopq
rstuvwxyzARGW_
ARS LONGA
VITA BREVIS
Amsterdam FirmaN

UNTITLED
ALPHABET, 1928
DESIGNER: ANDRÉ VLAANDEREN
KOSMOS, AMSTERDAM

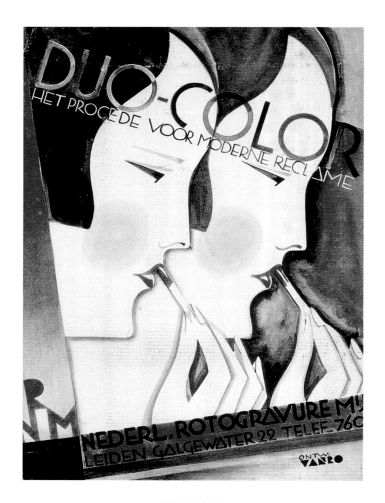

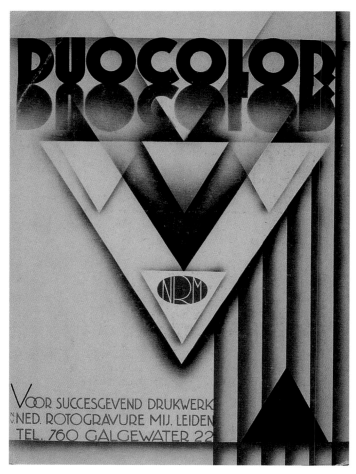

DUO COLOR

ADVERTISEMENT, 1930

DUO COLOR

ADVERTISEMENT, 1929

That a spiky gothic called Fraktur once was the standard German typeface was, perhaps, one reason for the severity of all German letterforms. Another was the visual landscape. Although a type reform movement emerged during the early 1900s which sought to replace Fraktur with more aesthetic letterforms, German display types were characteristically bolder than other European varieties. Even Futura, Paul Renner's paean to Modernism, was black. Deco type was born in Germany on posters created in Berlin and Munich. The leading posterists of the *Sachplakat* (object poster) and **GERMANY** *Berlin Plakat* (Berlin poster) schools used what were referred to as block letters as headlines on their advertisements. Block letters were usually drawn with a brush rather than a stylus or pen and, as the name suggests, were bold and eye-catching from a distance. Initially, most of these block letters were one-of-a-kind designs rendered exclusively for the posters. Ultimately the leading foundries, including Bauer, Flinsch, Berthold, and Stempel, realizing the commercial potential for advertisements and labels, introduced type families based on designs by Lucian Bernhard, Louis Oppenheimer, and other popular poster designers. Ohio is one of many typefaces informed by hand-rendered letterforms. In addition to quirky brand-name faces such as Metropolis and Omega, German commercial art studios created scores of nameless novelty faces in vibrant poster colors that were presented on specimen sheets and designed to be copied by other artists.

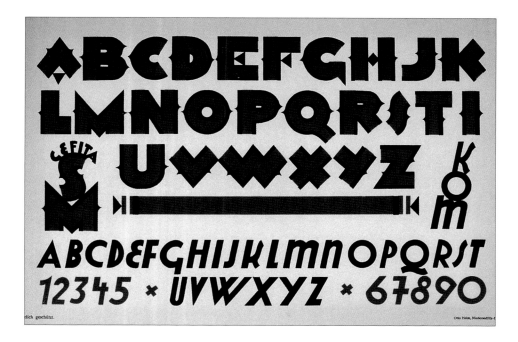

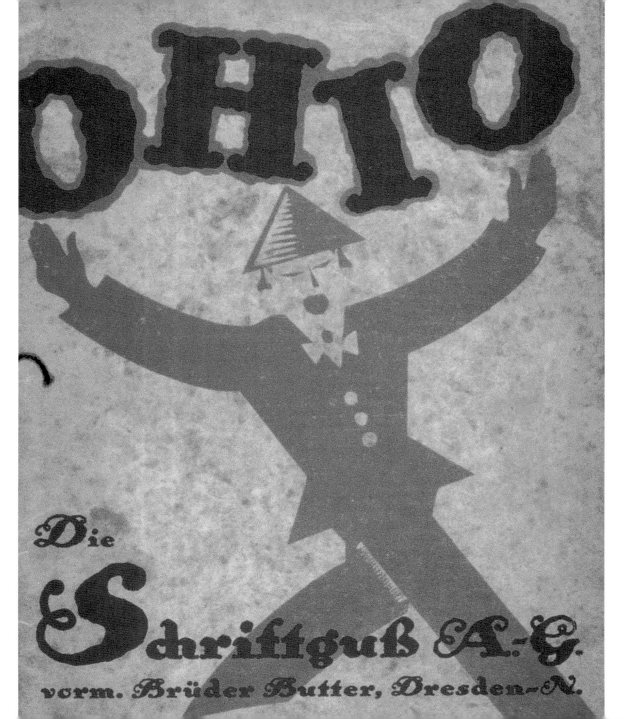

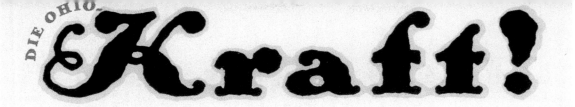

Kraft!

Die Lebenslust hat nicht den Grund im bloßen Sein, im steten Werden liegt des Lebens Reiz allein
Nr. 1162 (Petit)
Nicht was ich schon habe, sondern was ich schaffe, das ist mein Reich
Min. ca. 6 kg 20/30 A 106 a

Einladung zum Besuche der Vortragskurse ⚬ VOLKSHOCHSCHULE BOCHUM
Nr. 1163 (Korpus)
Verschwendete Zeit ist Dasein, gebrauchte ist Leben
Min. ca. 8 kg 16/24 A 80 a

Nur der verdient sich Freiheit wie das Leben, der täglich sie erobern muß
Nr. 1164 (Cicero)
Zeitgemäße Neuschöpfungen in Wort und Bild
Min. ca. 10 kg 16/24 A 80 a

Historische Kulturwerke ⚬ DEUTSCHES REICHSMUSEUM
Nr. 1165 (Mittel)
Kleinodien aus Gegenwart und Altertum
Min. ca. 12 kg 14/20 A 72 a

Vereinigung Freunde edler Kunst, Gruppe Coblenz
Nr. 1166 (Tertia)
Holländische Expressionisten
Min. ca. 14 kg 12/16 A 52 a

Sonderausstellung: ZEICHNUNGEN
Nr. 1167 (Text)
Albrecht - Dürer - Bund
Min. ca. 16 kg 8/12 A 34 a

Die Meistersinger von Nürnberg
Nr. 1169 (Doppelm.)
Staatsoper Eisenach
Min. ca. 20 kg 6/8 A 30 a

Ouvertüre aus MIGNON
Nr. 1170 (3 Cicero)
Melodienschatz
Min. ca. 24 kg 6/6 A 20 a

Novellen, Balladen
Nr. 1171 (4 Cicero)
Anekdoten
Min. ca. 30 kg 4/4 A 14 a

Von 10 Cicero ab als Holzschrift lieferbar!

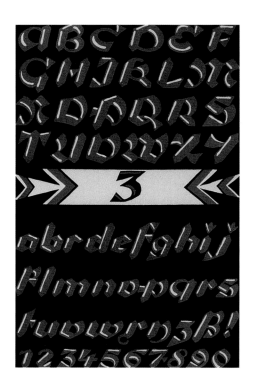

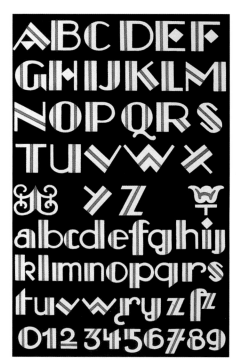

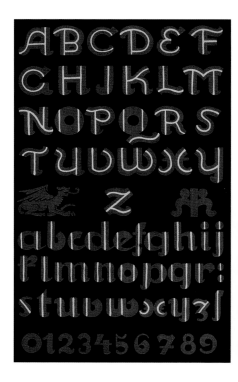

UNTITLED
ALPHABET, 1925
DESIGNER: OTTO HEIM
FARBIGE ALPHABETE

UNTITLED
ALPHABET, 1925
DESIGNER: OTTO HEIM
FARBIGE ALPHABETE

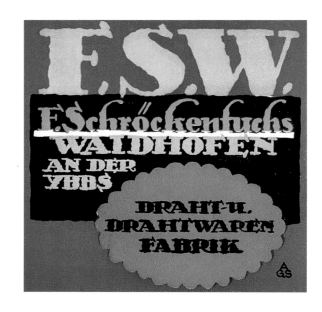

EX LIBRIS

BOOKPLATE, 1920

DESIGNER: HERBERT BAYER

F.S.W.

ADVERTISEMENT, 1918

DESIGNER: HERBERT BAYER

EX LIBRIS

BOOKPLATE, 1919

DESIGNER: HERBERT BAYER

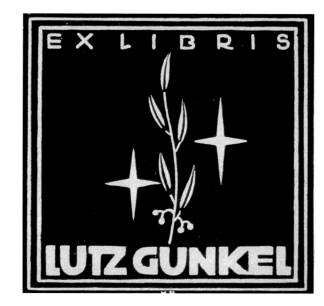

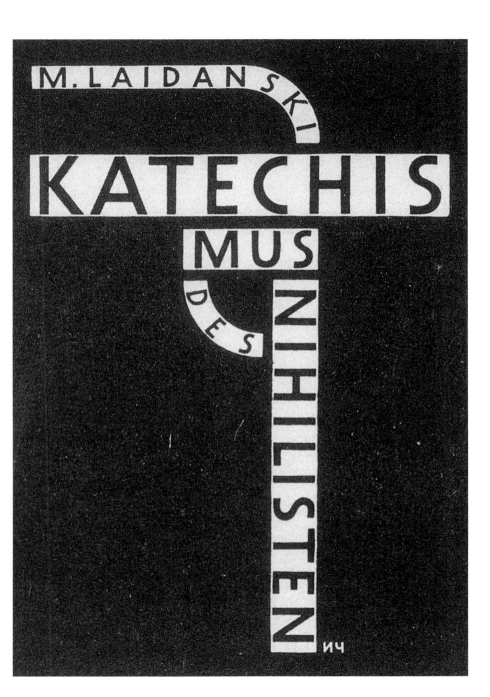

KATECHIS
BOOK JACKET, C. 1932
DESIGNER: NY

KATECHIS
BOOK JACKET, C. 1932
DESIGNER: NY

DAS KUNSTHAUS
LOGO, 1920
DESIGNER: HERBERT BAYER

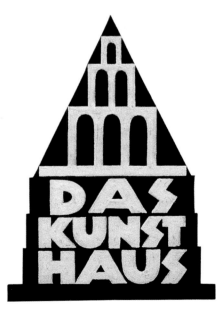

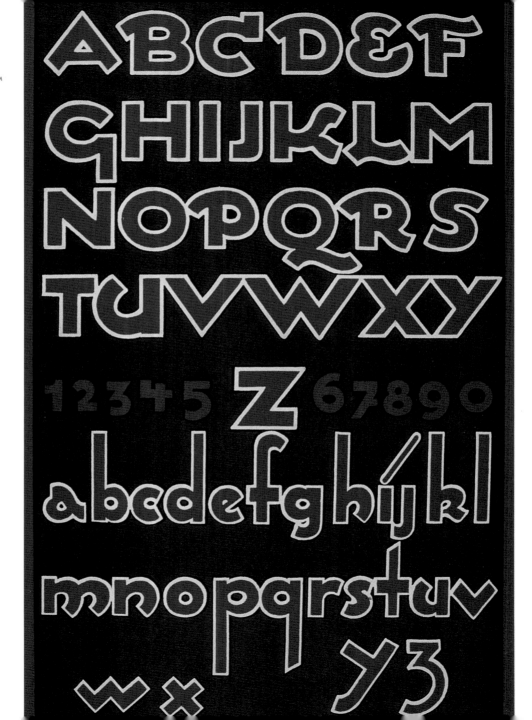

Bettina
ist der
Qualitäts-Stiefel

für Damen und Herren der eleganten Welt. Sehr moderne Formen, tadelloser Sitz, sauberste Verarbeitung und größte Haltbarkeit sprechen für seine Vorzüge. Mäßige Preise bieten die Möglichkeit zur Anschaffung für alle Bevölkerungsschichten. Die Einführung des „Bettina"-Stiefels bringt ständige Kundschaft und großen Nutzen.

ÜBERALL ERHÄLTLICH

in unseren Berliner Geschäften und Filialen in jeder größeren deutschen Stadt. Wo noch nicht plaziert, rührige Vertreter gesucht. Interessenten erhalten kostenlos unsere neue reich illustrierte Preisliste A zugesandt. Postbestellungen gegen Voreinsendung des Betrages (Postscheckkonto Berlin W30, Nr. 5240) oder gegen Nachnahme.

KURT BECK
BERLIN W30, FRANKENSTR. 8. TEL. LÜTZOW 5

VON A

Alles was der Tischler braucht

Hobelbänke, Leimapparate, Fournierpressen, Eisen- und Holzschraubknechte, Türen-Spanner, Hobel, Stechbeitel, Sägen, Feilkluppen, Zangen, Feilen, Stoßladen, kurz jedes

Werkzeug

zur Holzbearbeitung findet man bei mir stets am Lager. Außerdem führe ich Holzbearbeitungsmaschinen aller bekannten und bewährten Fabrikate. Ferner sämtliche

Ersatzteile

als Hobelwellen, Hobeleisen, Winkelanschläge, Vorgelege für alle Maschinen, Scheiben zum Schleifen, Sägenblätter, Sägenarme, Werkzeughefte, Schlaglof für Bandsägen etc.

Nutzholz

kauft man vorteilhaft auf meine neben dem Laden gelegenen Pla

ERICH HENSEL
MÜNZSTR. 14 ★ TEL.: ALEXANDER 2481
GRÖSSTES FACHGESCHÄFT IN BERLIN

BIS Z

H. BERTHOLD AG

DIE LO SCHRIFTEN

TYPE SAMPLE, 1920

DESIGNER: LOUIS OPPENHEIM

H. BERTHOLD A.G.

Drucksachen-Interessenten erkannten:
Unsere Block steht wie ein Fels in dem
Kommen und Gehen der Modeschriften
DER BESTE ERFOLG IST STETS REKLAME

Porträts in allen Größen werden
hier sauber und gut angefertigt
KUNSTHANDLUNG FRITZ WEBER

Herbst- und Frühjahrsmode
erregen lebhaftes Interesse
NEUHEITEN IN SEIDENROBEN

Elegante Damen-Wäsche
in tadelloser Ausführung
12345 CHEMNITZ 67890

Rheinisches Winzerfest
LIEDER ZUR HARFE

Feinweberei Hanau
SEIDENMÄNTEL

Weihnachtsfeier
PROGRAMM

Körperpflege
VOLKSBAD

Lieder-Buch
MUSIKHAUS

Druckerei
REISBACH

Kuratel
STORCH

Nabe
GREIF

Bank
HEIM

In den Graden von Corps 12 großes Bild an werden die nachstehend abgedruckten
Figuren in Form eines Zusatz-Sortiments abgegeben

a b d n o p s H C D E F K L N O R S / // ST T

H. BERTHOLD AG.

Als elementarer Grundsatz für die
Reklame gilt, daß sie wohl stark,
aber nur angenehm in sorgfältig
erwogenen Formen auffallen soll
DIE NEUEN KUNSTRICHTUNGEN IM
WERBEWESEN UND IHRE FEHLER

Wenn auch zurzeit alles den
aufgelösten Satz bevorzugt
und den Blocksatz verpönt
SCHRIFT UND FLÄCHE IN DER
NEUZEITLICHEN DRUCKSACHE

Der Besuch unsrer neuen
Räume am Moltke-Platz 1
wird Sie sehr befriedigen
GRUNDMANN & ZUMBECK

Handels-Nachrichten
von allen Plätzen des
Kontinents für Tabak
1234 HAMBURG 5678

Brahls Schuhwaren
werden hergestellt
aus gutem Material
FRANKFURT/MAIN

Pflegt klassische
Musik aus Opern
BECHSTEINHAUS

Holz und Stein
in der Bauwelt
ARCHITEKTUR

Erzschmelze
ZECHE RUHR

Gemeinde
KREMMEN

Burgund
SPANIEN

Wachau
MARSCH

Ostern
REITER

Gnom
NAME

H. BERTHOLD AG.

Seltene Bücher des Mittelalters

Nordischer Künstlerbund

Aparte Modeartikel

HÖHE METROPOLIS

TYPE SPECIMEN, 1932

DESIGNER: W. SCHWERDTNER

D. STEMPEL A.G.

METROPOLIS BOLD

REGISTER

Household

36 Point
3A-6a $10.60

ROMAN

Material

48 Point
3A-5a $15.60

HOME

Nature

60 Point
3A-4a $18.80

METROPOLIS BOLD

TYPE SPECIMEN, 1932

DESIGNER: W. SCHWERDTNER

CONTINENTAL TYPEFOUNDERS ASSOCIATION

Unheard of values in Men's Shoes!

METROPOLIS BOLD
TYPE SAMPLE, 1932
DESIGNER: W. SCHWERDTNER
CONTINENTAL TYPEFOUNDERS ASSOCIATION

Today only, June **10**

$6

Regularly to $10

Lidds

Lidd Brothers Shoes have a pronounced flair for quality, comfort and style. The models included in this sale have all been in our regular stock. Such popular leathers as the scotch grain, calf, and the new Gibralter are featured. All to be closed out at one price--$6

HUMBERT AVENUE AT NINETEENTH STREET

LICHTE METROPOLIS
TYPE SPECIMEN, 1932
DESIGNER: W. SCHWERDTNER
D. STEMPEL A.G.

Nr. 63534 c, Doppelmittel, 28 Punkt, Satz etwa 6 kg, 10 A

LITERARISCHE WERKE

Nr. 63535, 3 Cicero, 36 Punkt, Satz etwa 9 kg, 10 A

DANTES DICHTUNG

Nr. 63530, 4 Cicero, 48 Punkt, Satz etwa 12 kg, 10 A

SAGENSCHATZ

GESCHNITTEN VON 20-48 PUNKT

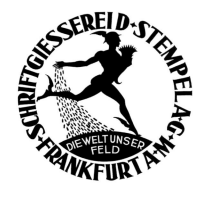

SCHRIFTGIESSEREI D. STEMPEL A.G.
LOGO, C. 1925
D. STEMPEL A.G.

OMEGA
TYPE SAMPLE, 1926
DESIGNER: F. KLEUKENS
D. STEMPEL A.G.

VII. FRANKFURTER

INTERNATIONALE

FRÜHJAHRSMESSE

HAUS WERKBUND

HAUS OFFENBACH

HAUS DER MODEN

HAUS DER TECHNIK

FÜR DAS WERBEWESEN SCHUFEN WIR
NACH ZEICHNUNGEN ERSTER KÜNSTLER
EINE REIHE BEDEUTENDER SCHRIFTEN
DIE DEN ANFORDERUNGEN MODERNER
WERBETECHNIK IN ANERKANNT HERVOR
RAGENDEM MASSE ENTSPRECHEN UND
FÜR DRUCKE ALLER ART JE NACH INHALT
UND ZWECK DER WERBUNG GEEIGNETE
GESTALTUNGSMÖGLICHKEITEN BIETEN

KABEL
TYPE SAMPLE, 1930
DESIGNER: RUDOLF KOCH
KLINGSPOR

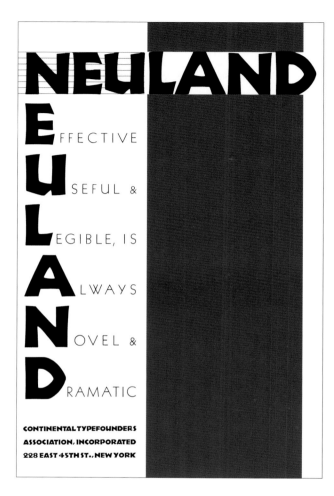

NEULAND
TYPE SPECIMEN COVER, 1923
DESIGNER: RUDOLF KOCH
CONTINENTAL TYPEFOUNDERS ASSOCIATION

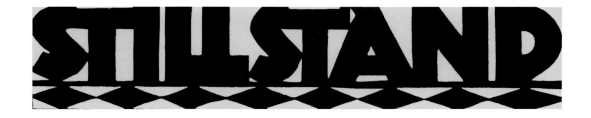

STILLSTAND

LETTERHEAD, 1927

DESIGNER: M. GLADBACH

FROM *KUNSTSCHRIFT UND SCHRIFTKUNST*

JOSEPH HERBER

LETTERHEAD, 1927

DESIGNER: M. GLADBACH

FROM *KUNSTSCHRIFT UND SCHRIFTKUNST*

B. HOLLWEID

LETTERHEAD, 1927

DESIGNER: M. GLADBACH

FROM *KUNSTSCHRIFT UND SCHRIFTKUNST*

UNTITLED
ALPHABET, C. 1929
SCHOOL OF DECORATIVE ART, STUTTGART

UNTITLED
ALPHABET, 1929
DESIGNER: PAUL KLEIN

CAPITALES KRESS
ALPHABET, 1929
DESIGNER: OSKAR KRESS

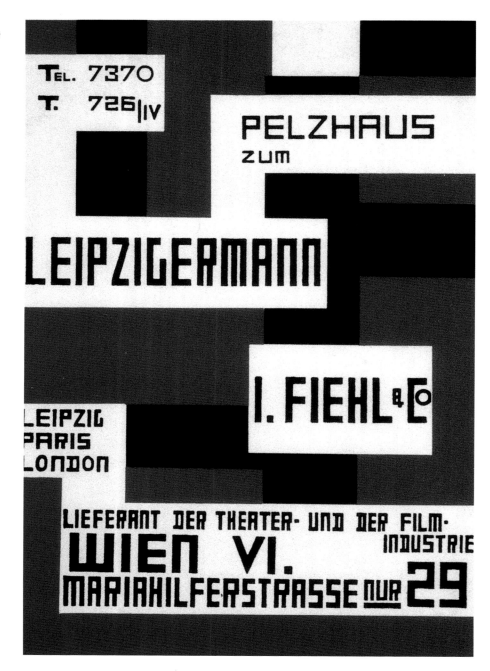

BAUHAUS WEIMAR

BOOK COVER, 1924

DESIGNER: JOOST SCHMIDT

BAUHAUS WEIMAR

EXHIBITION POSTER, 1923

DESIGNER: JOOST SCHMIDT

MUSIK UND

THEATERFEST WEIMAR

CATALOG COVER, 1924

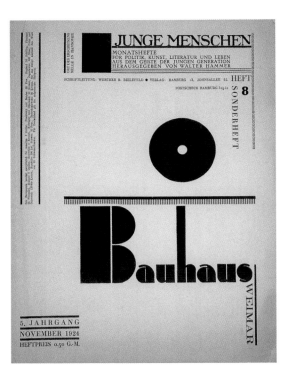

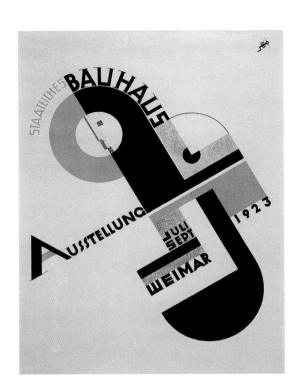

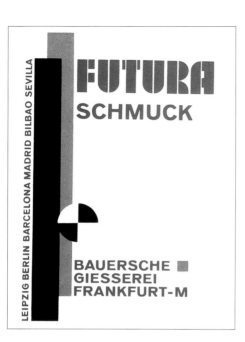

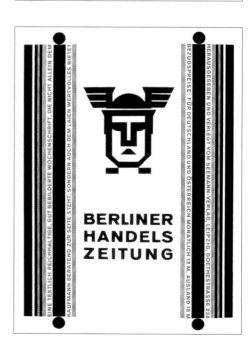

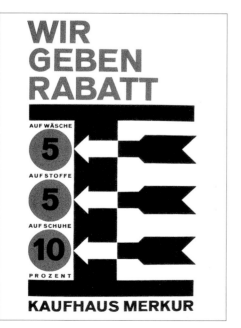

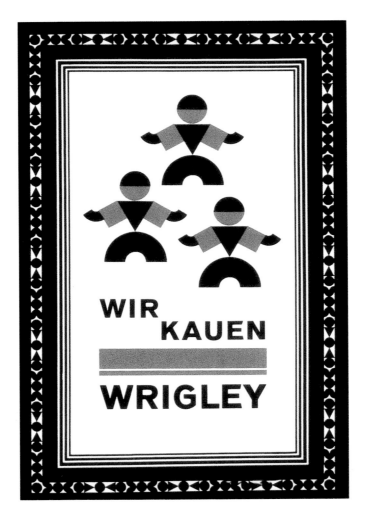

WIR HABEN INTERESSE FÜR IHRE

FUTURA

UND BITTEN UM IHR ANGEBOT

WIR
KAUEN

WRIGLEY

FUTURA

TYPE SAMPLE, C. 1930

DESIGNER: PAUL RENNER

BAUERSCHE GIESSEREI

FUTURA SCHMUCK

ORNAMENT SAMPLE, C. 1930

BAUERSCHE GIESSEREI

The Futurists, Italy's cultural avant garde, revolutionized typography, which they believed was imprisoned in the rotting wood of antiquity. The Futurists introduced a typographic language that called for discordant typefaces to appear disharmoniously on the same page. This approach, referred to as Words in Freedom, ignored any semblance of symmetry, and the raucous designs approximated the sounds of words. Yet the artists originally worked with existing letterforms — slab-serif wood types and bold sans-serif metal types — that evoked the nineteenth century even as they revolted against it. In the **ITALY** early 1920s, Futurism's influence on advertising layout included use of an array of more dynamic hand-drawn letters. Sharp-edged gothics in stair-step shapes contributed to the improvisational nature of their work. More expressive and freer than classical Roman letters, the new styles moved quickly off the Futurist manifestos and into mass commercial art. From posters for liquor and cigarettes to Fascist propaganda, graphic designers adopted novel typography in order to appeal to Italian youth. The Modern rejection of tradition, however, was not total. Although typographic standards were routinely challenged, typography in Italy, the birthplace of modern type, was nevertheless taken seriously. Futurism's rejection of tradition may have been a great influence, but designers continued to use venerable scripts and Roman faces that were often revised in a contemporary manner in an effort to adhere to the spirit of *Italianismo*.

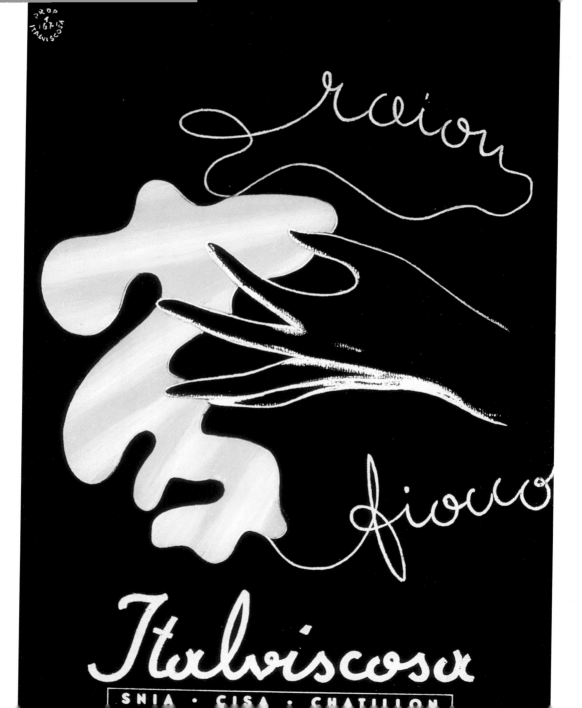

ITALVISCOSA
HAND-LETTERED
POSTER, C. 1933

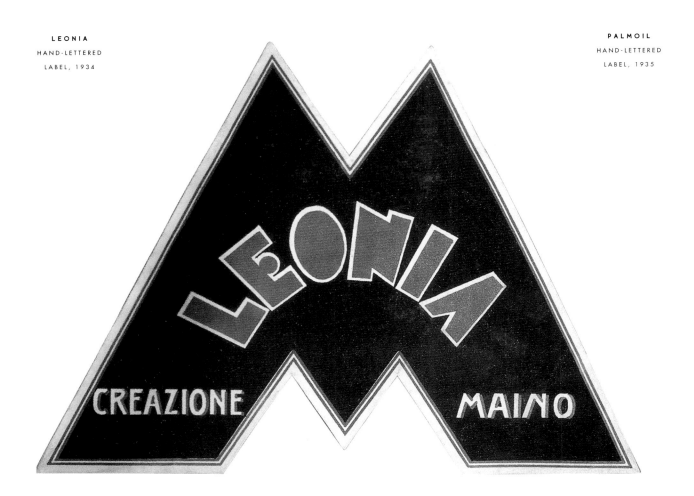

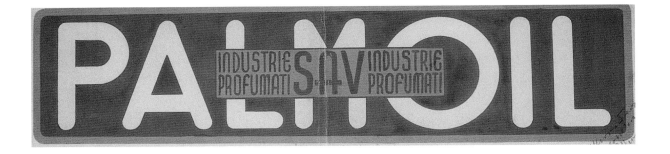

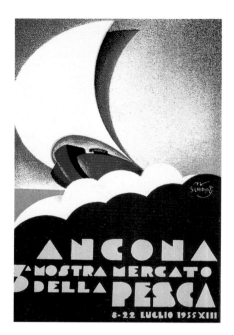

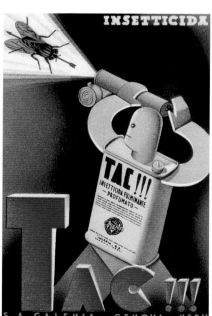

ANCONA
HAND-LETTERED
POSTER, 1931

L'ORBE E L'UOMO
HAND-LETTERED
BOOK JACKET, 1929

TAC
HAND-LETTERED
POSTER, C. 1930

LA STIRPE
HAND-LETTERED
MAGAZINE COVER, C. 1931

(OPPOSITE)
LE GRANDI FIRMI
HAND-LETTERED
MAGAZINE COVER, 1934

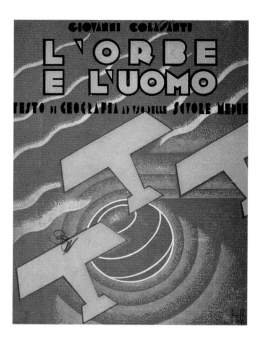

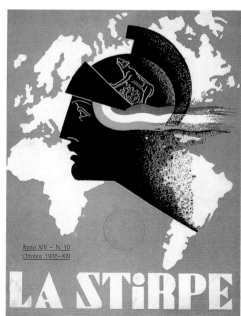

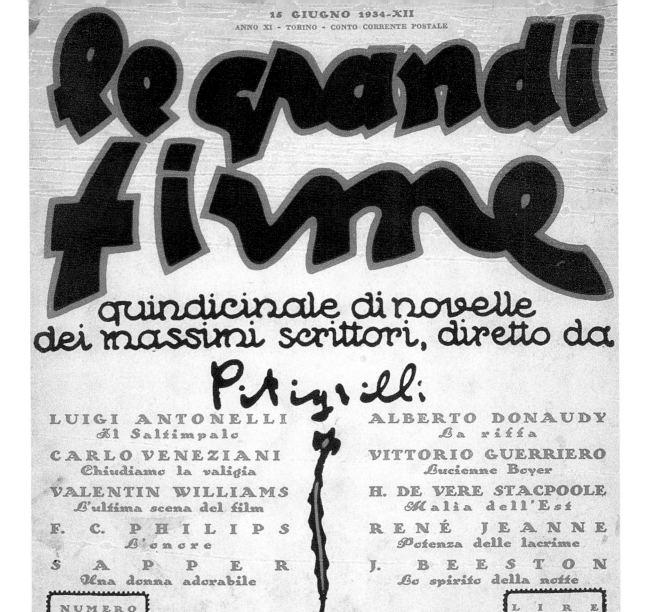

15 GIUGNO 1934-XII

ANNO XI - TORINO - CONTO CORRENTE POSTALE

Le grandi firme

quindicinale di novelle dei massimi scrittori, diretto da

Pitigrilli

LUIGI ANTONELLI
Il Saltimpalo

ALBERTO DONAUDY
La riffa

CARLO VENEZIANI
Chiudiamo la valigia

VITTORIO GUERRIERO
Lucienne Boyer

VALENTIN WILLIAMS
L'ultima scena del film

H. DE VERE STACPOOLE
Malia dell'Est

F. C. PHILIPS
L'onore

RENÉ JEANNE
Potenza delle lacrime

SAPPER
Una donna adorabile

J. BEESTON
Lo spirito della notte

NUMERO
240

LIRE
1,50

Leonardo Merrick: *Il cacciatore di fantasmi* - CLAN

99

UMBERTO
HAND-LETTERED
PACKAGE SAMPLE, 1932

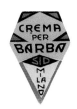

LANCELLOTTI
HAND-LETTERED
LABEL, 1932

CREMA PER BARBA
HAND-LETTERED
LABEL, 1935

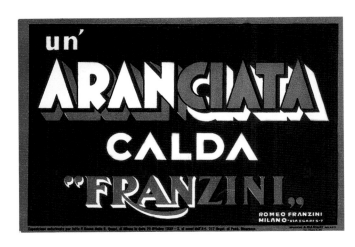

FRANZINI
HAND-LETTERED
LABEL, 1935

At the turn of the century, Russian graphic artists engaged in type reforms. Sinuous Cyrillic letterforms echoing those designed in Germany and France were used for posters and magazines. In the aftermath of the 1917 Russian Revolution, a progressive visual arts movement known as Constructivism emerged. Among its missions was elevation of visual and verbal literacy throughout Russia. In this scheme, type design was elemental; letters were constructed using typecase "furniture," free of adornment and thus extremely accessible and readable. Stark type layouts

RUSSIA & EASTERN EUROPE

were traffic signs on the road of comprehension. Not all printers and typographers completely subscribed to what the German typographer Jan Tschicold called "Elementary Typography," but the influence was profound throughout Russia and abroad. Czechoslovakia, Hungary, and Poland enjoyed vital cultural avant gardes that in turn influenced publishing and advertising design. Trade publications, including *Typografia* in Prague, *Magyar Grafika* in Budapest, and *Grafika* in Warsaw, introduced designers to the trends in Modern and moderne graphics while promoting the fashions unique to each country. Advertising in these burgeoning industrial centers required hard-sell designs, but the typography did not slavishly follow the West. In these Eastern European countries, commercial artists wed modernity to a national style, resulting in a unique hybrid.

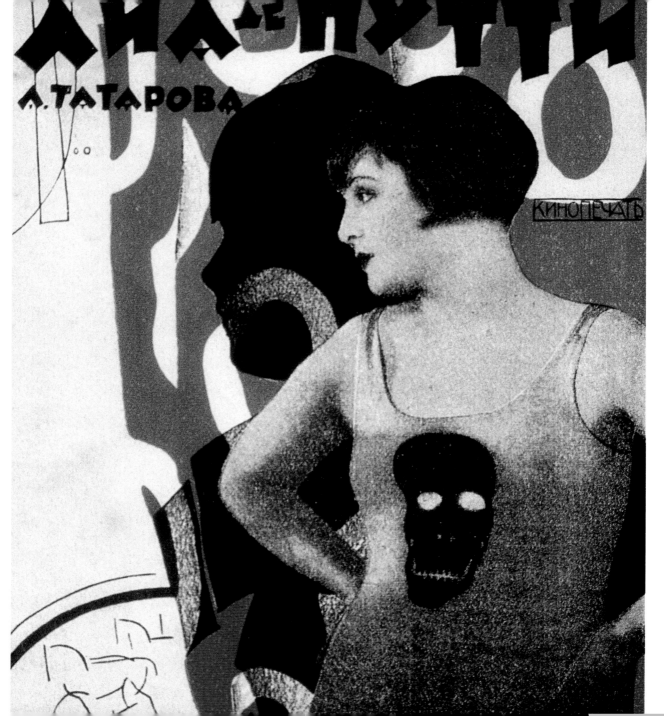

(PREVIOUS PAGE)
ANA POTTI
(RUSSIA)
HAND-LETTERED
BOOK COVER, 1928

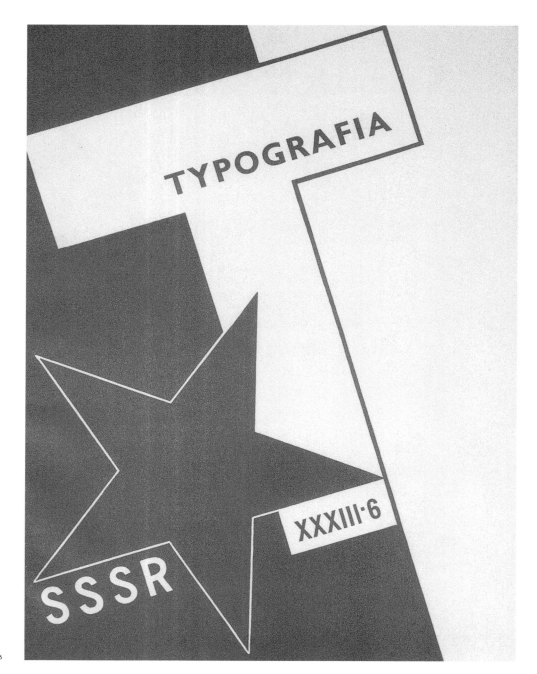

TYPOGRAFIA
(CZECHOSLOVAKIA)
MAGAZINE COVER, 1926

TYPOGRAFIA
(CZECHOSLOVAKIA)
MAGAZINE COVER, 1931

BOOK JACKETS

(CZECHOSLOVAKIA), 1929–82

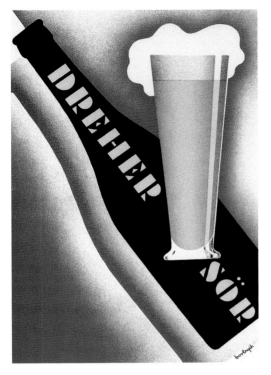

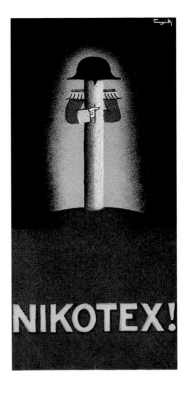

DREHER SÖR

(HUNGARY)

POSTER, C. 1928

DESIGNER: BORTNYK

BUÉK

(HUNGARY)

BUSINESS CARD, C. 1928

NIKOTEX!

(HUNGARY)

POSTCARD ADVERTISEMENT, C. 1926

MAÎTRE BRUSQUET

(HUNGARY)

CANDY WRAPPER, 1927

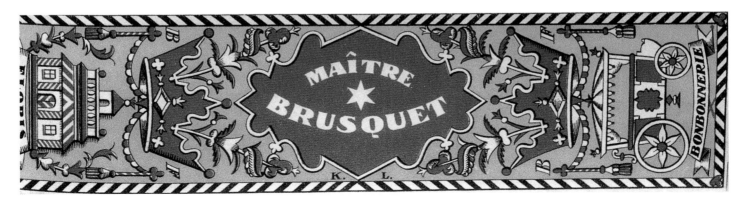

AVIATIKA

(HUNGARY)

MAGAZINE COVER, 1931

DESIGNER: BISITS TIBOR

(OPPOSITE)

MAGYAR GRAFIKA

(HUNGARY)

MAGAZINE COVER, 1931

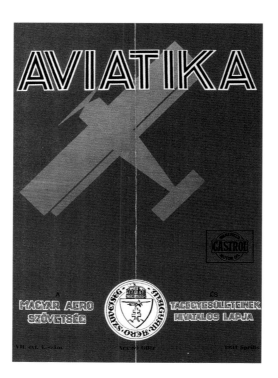

NÉZZE MEG

(HUNGARY)

BUSINESS CARD, 1928

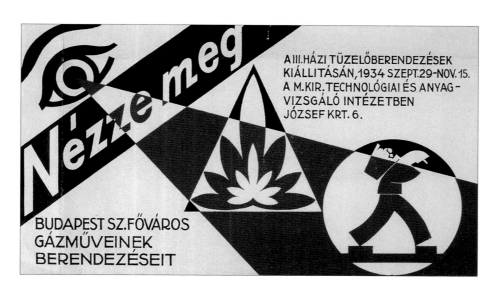

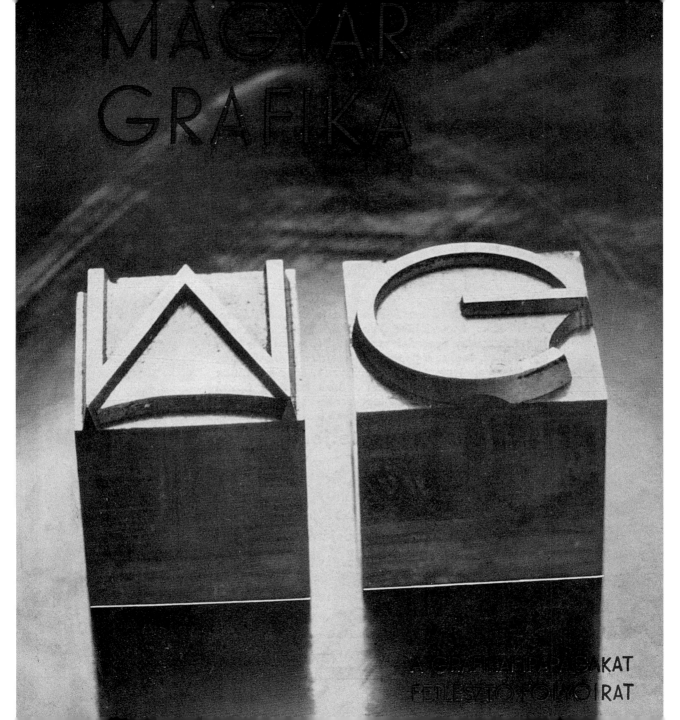

MAGYAR
GRAFIKA

A GRAFIKAI IPARÁGAKAT
FEJLESZTŐ FOLYÓIRAT

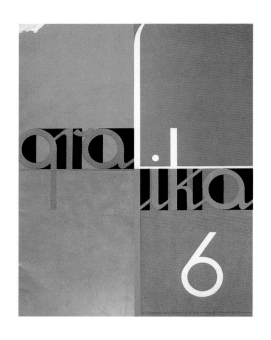

GRAFIKA

(POLAND)

MAGAZINE COVER, 1931

DESIGNER: ADAM POLTAWSKI

GRAFIKA

(POLAND)

MAGAZINE COVER, 1931

DESIGNER: TADEUSZ GRONOWSKI

GRAFIKA

(POLAND)

MAGAZINE COVER, 1932–33

DESIGNER: W. ZANVIDZKA

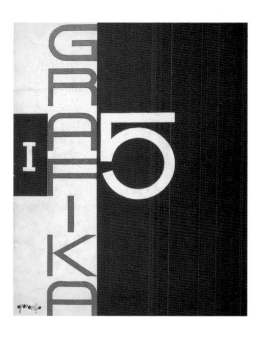

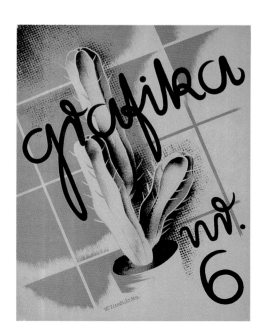

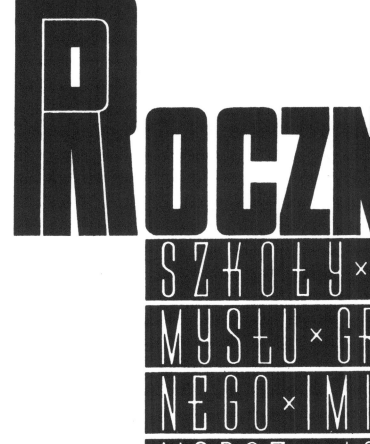

ROCZNICK
(POLAND)
CATALOG COVER, 1936
DESIGNER: I. RUBIN

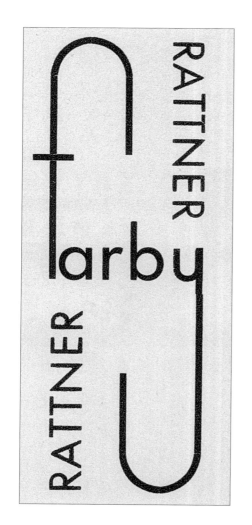

RATTNER FARBY

(POLAND)

LOGO, 1936

DESIGNER: A. SZTERNER

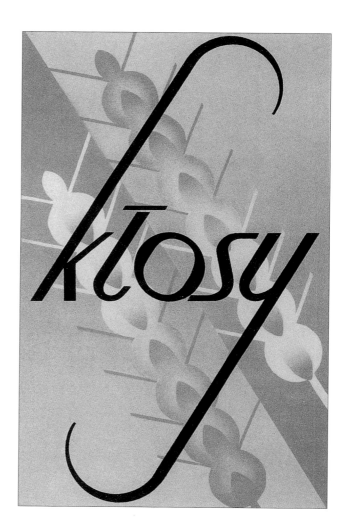

KŁOSY

(POLAND)

CATALOG COVER, C. 1935

DESIGNER: SZKOLA PRZEMYSLU

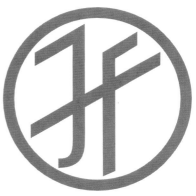

JF
(POLAND)
LOGO, C. 1931

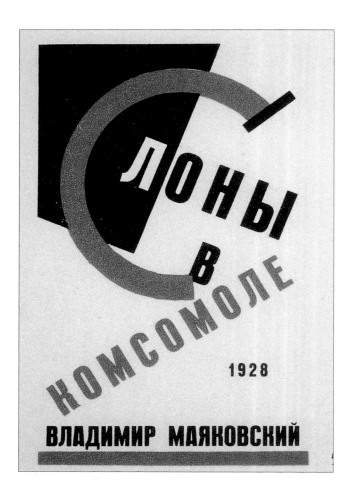

ELEPHANTS IN KOMSOMOL

(RUSSIA)

BOOK JACKET, 1928

DESIGNER: NICOLAI ILIJIN

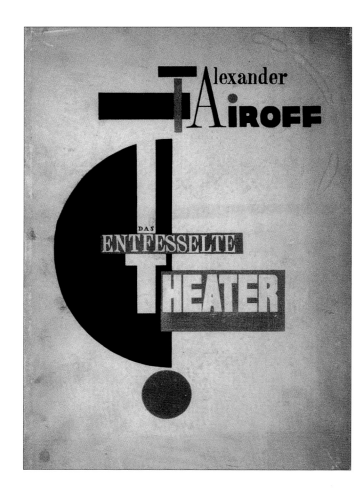

ENTFESSELTE THEATER

(RUSSIA/GERMANY)

BOOK JACKET, 1927

DESIGNER: LAZAR EL LISSITZKY

REVOLUTIONARY TORNADO

(RUSSIA)

BOOK JACKET, 1926

DESIGNER: NICOLAI ILIJIN

THE THEATRICAL LINE

(RUSSIA)

BOOK JACKET, 1926

DESIGNER: NICOLAI ILIJIN

othing would appear to be more foreign, yet was so similar, to American and European styles than Japanese typography. In the period between the wars, Japan's consumer culture was profoundly influenced by the West. Prior to the 1920s, Japanese advertising had been rooted in traditional woodcut graphics and kanji characters. Then industry began to boom, and a new breed of designer ventured West and brought back examples of European design. The most influential document was *The Complete Commercial Artist (1928-1930)*, a twenty-four volume series devoted to **JAPAN** teaching European design techniques to Japanese designers. Included were lessons on poster, sign, logo, package, point of purchase, store window, and, of course, type design. Designers combined a distinctly Japanese point of view with the Western formulas for effective sales. In the realm of typography, Japanese characters were streamlined with motion lines and sunbursts. Although the faces were rarely given the symbolic names of their Western counterparts, there was no mistaking the derivation. European faces were hybridized in type catalogs. Scores of novelty Roman alphabets were used, sometimes in conjunction with similarly styled kanji, in a range of brochures and signs and on the ubiquitous Japanese matchbox. By 1936, when the nationalists assumed control of the government and firmly discouraged outside influences, the majority of Japanese commercial art was European.

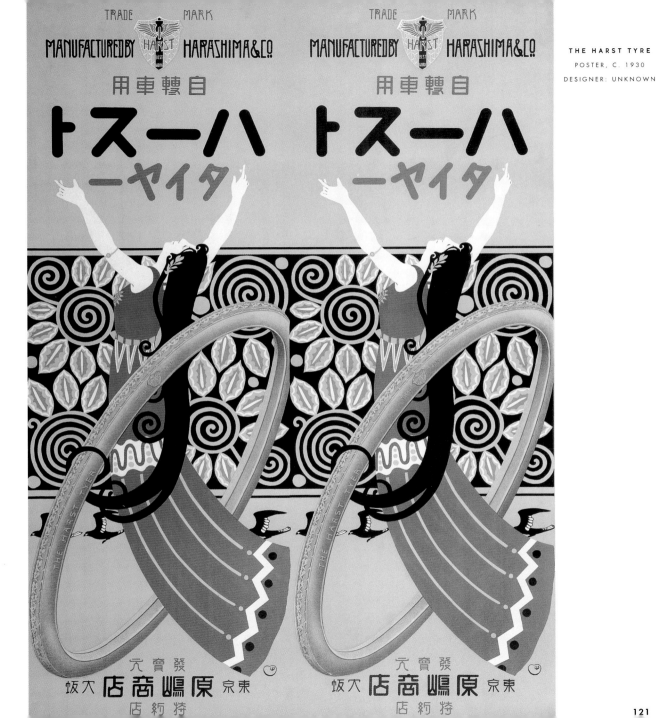

THE HARST TYRE
POSTER, C. 1930
DESIGNER: UNKNOWN

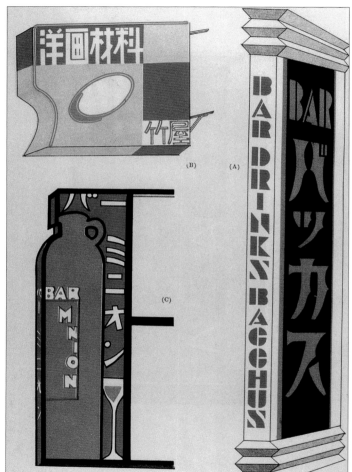

LETTERING SPECIMENS

1927

FROM *THE COMPLETE COMMERCIAL ARTIST*

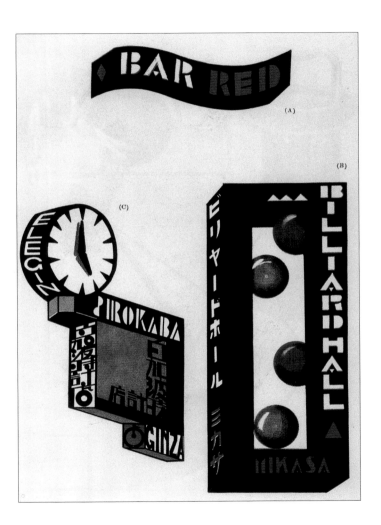

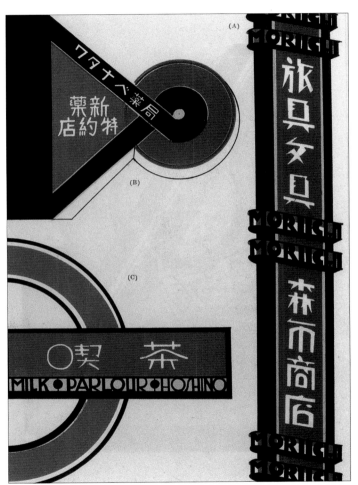

LETTERING SPECIMENS

1927

FROM *THE COMPLETE COMMERCIAL ARTIST*

ALPHABETS
1926
DESIGNER: YAJIMA SHUICHI

(OPPOSITE)
ALPHABET (ROMAN LETTERS)
1926
DESIGNER: YAJIMA SHUICHI

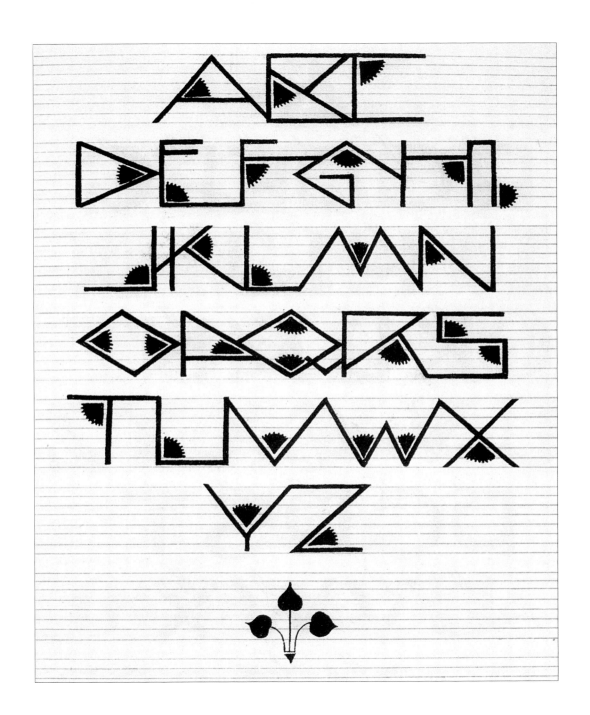

LETTERING SPECIMEN
1927
DESIGNER: HAMADA MASUJI
FROM *THE COMPLETE
COMMERCIAL ARTIST*

TOOTHPASTE
1927
DESIGNER: HAMADA MASUJI
FROM *THE COMPLETE
COMMERCIAL ARTIST*

THEATER PROGRAM COVER

1928

BASED ON POSTER BY JEAN CARLU

ALPHABETS (ROMAN LETTERS)

1926

DESIGNER: YAJIMA SHUICHI

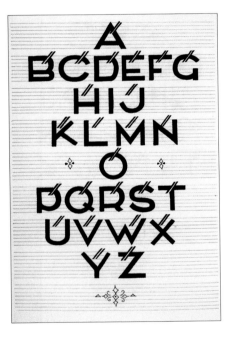

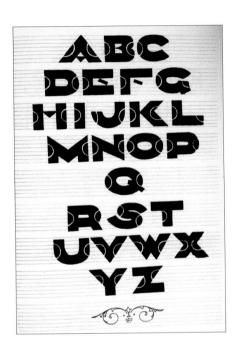

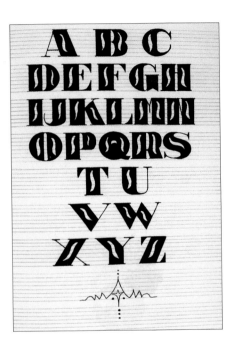

ALPHABETS (ROMAN LETTERS)

1926

DESIGNER: YAJIMA SHUICHI

BIBLIOGRAPHY

Busch, Hugo, and H. Cossmann. *Kunstschrift und Schriftkunst.* Düsseldorf: B. Kühlen Kunst und Verlaganstalt, 1927.

Carlyle, Paul, and Guy Oring. *Letters and Lettering.* New York: McGraw-Hill Book Company, 1935.

Cary, Melbert B., Jr. *Modern Alphabets.* New York: Bridgman Publishers, 1937.

Cohen, Arthur, and W. Michael Sheehe. *Ex Libris 6: Constructivism & Futurism: Russian & Other.* New York: Ex Libris, 1977.

Day, Harold Holland. *Modern Brush Lettering.* Cincinnati: The Signs of the Times Publishing Company, 1931.

Draim. *La Lettre Artistique and Moderne.* Paris: Monrocq Frères, 1928.

Duvillé, D. *Art du Tracé Rationnel de la Lettre.* Paris: Société Française d'Éditions Littéraires et Techniques, 1934.

Hunt, W. Ben, and Ed C. Hunt. *Lettering of Today.* Milwaukee: The Bruce Publishing Company, 1935.

Eson, Ron, and Sarah Rookledge. *Rookledge's International Directory of Type Designers: A Biographical Handbook.* New York: The Sarabande Press, 1994.

Gress, Edmund G. *Fashions in American Typography, 1780–1930.* New York: Harper & Brothers Publishers, 1931.

Hoffman, Herbert with Albert Bruckner, Max Hertwig, and Rudolf Koch. *Alphabets.* Paris: Arts et Métiers Graphiques, 1933.

Hollister, Paul. *American Alphabets.* New York: Harper & Brothers Publishers, 1930.

Jahrbuch der Schriftgiesserei. Frankfurt: D. Stempel A.G., 1929.

McMurtrie, Douglas C. *Modern Typography and Layout.* Chicago: Eyncourt Press, 1929.

Stevens, Thomas Wood. *Lettering.* New York: The Prang Company, 1916.

Welo, Samuel. *Lettering Modern and Foreign.* Chicago: Frederick J. Drake, 1930.